Step-by-Step
LIGHTING *for* OUTDOOR
PORTRAIT PHOTOGRAPHY

D0943402

Jeff Smith
AMHERST MEDIA, INC. BUFFALO, NY

About the Author

Jeff Smith is a professional photographer and the owner of two very successful studios in central California. His numerous articles have appeared in *Rangefinder, Professional Photographer,* and *Studio Photography and Design* magazines. Jeff has been a featured speaker at the Senior Photographers International Convention, as well as at numerous seminars for professional photographers. He has written seven books, including *Outdoor and Location Portrait Photography; Corrective Lighting, Posing, and Retouching Techniques for Portrait Photographers; Professional Digital Portrait Photography;* and *Success in Portrait Photography* (all from Amherst Media®). His common-sense approach to photography and business makes the information he presents both practical and very easy to understand.

Copyright © 2014 by Jeff Smith.
All rights reserved.
All photographs by the author.

Published by:
Amherst Media, Inc.
P.O. Box 586
Buffalo, N.Y. 14226
Fax: 716-874-4508
www.AmherstMedia.com

Publisher: Craig Alesse
Senior Editor/Production Manager: Michelle Perkins
Assistant Editor: Barbara A. Lynch-Johnt
Editorial Assistance from: Sally Jarzab, John Loder, Carey A. Miller
Associate Publisher: Kate Neaverth
Business Manager: Adam Richards
Warehouse and Fulfillment Manager: Roger Singo

ISBN-13: 978-1-60895-703-3
Library of Congress Control Number: 2013952488
Printed in The United States of America.
10 9 8 7 6 5 4 3 2 1

Check out Amherst Media's blogs at: http://portrait-photographer.blogspot.com/
http://weddingphotographer-amherstmedia.blogspot.com/

Contents

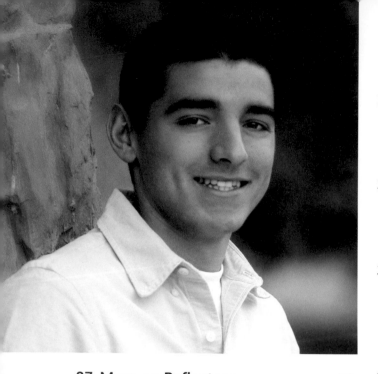

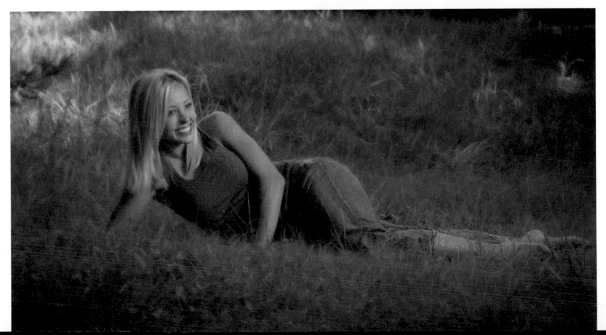

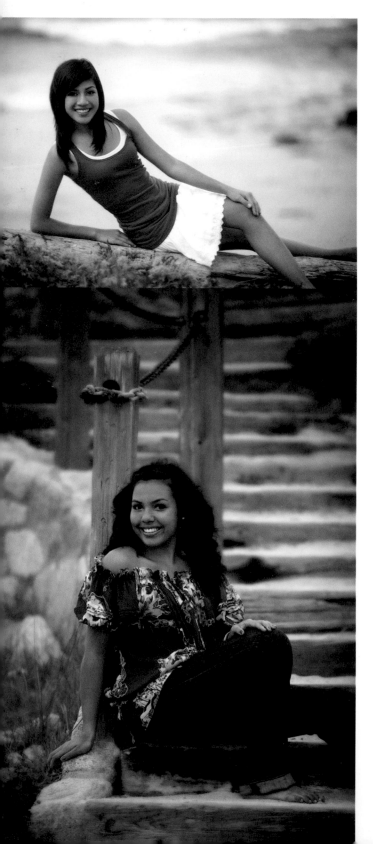

Images taken outside of a studio are some of the most striking and personalized portraits that we can create. Contrary to what many photographers think, however, outdoor portraits can be both efficient and profitable.

1. Cost Savings

In our studio, we photograph primarily high-school seniors. This requires a larger-than-normal variety of backgrounds, sets, and props. We have expensive sets from Off the Wall and Scenic Designs, countless painted backdrops, and a Harley Davidson motorcycle. We even have a Dodge Viper for our seniors to be photographed with (although that's kind of fun for me, too!).

Contrary to what many think, outdoor portraits can be both efficient and profitable.

All of these sets, all this money, and what is it for? It's an attempt to create unique environments for portraits. While I love my sets and the ease of working in the studio, there is a park right down the street from my studio where I can find bridges, arches, and walkways—scenes that offer a depth and complexity I can't begin to re-create in or around the studio. Best of all, these are mine to use anytime for a $2.00 admission fee. You definitely can't beat that for economy!

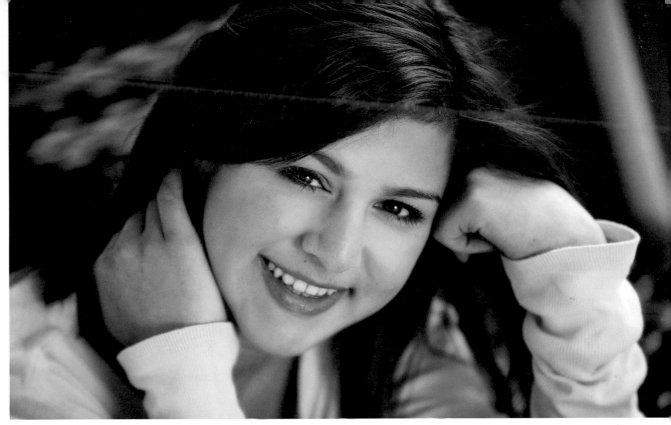

This page and facing page. Outdoor sessions provide a depth and complexity of backgrounds that you could only dream of producing with studio sets and backdrops.

2. Personalization

And when it comes to personalization, what could be more personal than photographing your client in their own backyard? Or at their favorite park or beach? Working with the client (whether we're talking about a senior, a bride, a family, or a child) in an environment where they feel comfortable also produces a more relaxed experience during the shoot.

3. Profits

While creativity is a good reason to go on location, a profit still has to be generated from each session to make it worthwhile. Travelling to and from locations can eat up a lot of a photographer's day. Therefore, many studios price location sessions so high that their average clients will not take advantage of them. This means that the client loses out on special portraits and you lose out on the additional profits they generate. In this scenario, no one wins. In this book, we'll look at a better way.

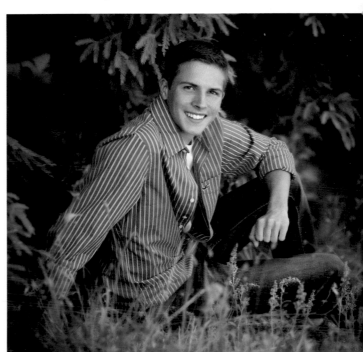

Big Changes

I have been in this industry for a few decades (I got an early start) and more has changed in professional photography in the last 10 years than in the 50 before then. This includes not only how we capture and edit our images, but the way in which the average photographer now works with his clients. Gone are the days when the majority of photographers who read my books had large studios with multiple indoor/outdoor shooting areas. Today's photographers are more likely to create outdoor portraits at a nearby park or beach—or even in a backyard (their own or the client's).

Who Is Teaching You?

Too common today are weekly "support groups," where photographers who know very little can teach the ones that know nothing at all. You have young photographers offering to be mentors to even younger photographers, which is simply crazy. If you take advice from students, you will forever be a student; if you learn from a master, you too can someday become a master. There is an old saying that has never been truer than in photography today: "Never take advice from anyone who isn't where you want to be."

Practice Properly

Yet, while a great deal has changed in our profession, there are still basic rules that form the foundation for a lasting career.

I believe strongly that the quality of your education will determine the quality of your photography and the longevity of your career.

Never take advice from anyone who isn't where you want to be.

Learning the fundamentals of lighting from a qualified instructor or mentor remains vitally important. Whether through college professors, professional seminars/workshops, or books like this, you need to learn about photography correctly—and preferably from someone who is already a successful professional photographer!

Some photographers skimp on education and hide their shortcomings with Photoshop, but that isn't a sustainable practice. To succeed, you have to learn and practice the correct way of doing things. Unfortunately, this idea of learning photography properly is sometimes regarded as "old school"—the way us "old guys" learned photography. The new way, many photographers claim, is for everyone to help each other (see "Who Is Teaching You?" to the left).

In my experience, you can only learn to do something properly by practicing how to do it properly. Sadly, I see younger photographers at

Above and facing page. If you take the time to educate yourself and practice, you won't need to hide behind your Photoshop skills. You'll have nice images straight out of the camera.

workshops who are struggling with the frustration and difficulty of trying to break bad habits they learned from other young photographers. Habits acquired based on incorrect information are hard to break; it's much better to train properly in the first place. In fact, I would rather hire a person with absolutely no knowledge of photography and train them than work with someone who has already developed bad habits. It isn't practice that makes perfect, it is *perfect* practice that makes perfect.

The Desire to Learn Is Common Ground

The desire to learn and become more proficient as photographers is the common ground on which both newbies and more established photographers can unite. We all need to become better—we all need to offer the buying public professional-quality photography. This means we need to get past this "us versus them" mind-set that often serves to divide older and younger photographers.

Good ideas are good ideas, whether they come from the younger photographers or the more established ones. In my business, I use all the brains I have and all that I can borrow. Whether an idea comes from the wisdom of the past or the vision of the future, if it helps my business, it's a great idea.

For the information in this book to be effective, you must not only *read* it but also *practice* it. The following is what I suggest.

1. Don't Rely on One Style

Many photographers want to learn one style of lighting that will satisfy all their clients and make every subject look beautiful. While some lighting styles work with a wide range of subjects, nothing is right for *everyone*. You

Ask yourself why the photographer made the lighting choices they did.

must know how to work with many styles of lighting and achieve many looks. This is one way true professionals set themselves apart from mere camera owners.

2. Study Portraits and Lighting

Look at the effects of lighting on different surfaces. Study the morning light on the bark of a tree, or the midday sun on a child's

Below and facing page. Study portraits and ask yourself about the photographer's lighting choices.

Too Eager for Change?

One of the things that makes my portraits look like *my* portraits is that I never changed my core style as I learned new techniques. Some of what I do today is based on skills I learned 25 years ago. It worked then and I never found anything better, so I didn't let the excitement of something new overwhelm the value of something that worked. My style of lighting, posing, and composition has certainly evolved, but my style has never changed outright. I like what I like (which is based on what my clients like and buy). I try new things all the time, but I use them to elevate my style, not to replace it.

face. Notice how the light emphasizes or minimizes texture and color.

Study portraits. Examine the fine detail (especially the eyes) to figure out where the photographer placed any added lighting or positioned the subject relative to the existing light. Ask yourself why the photographer made the lighting choices they did. You have to figure out *why* before you can understand the decisions and replicate the results.

3. Build on What You Know

As you read this book, don't abandon the techniques that you currently use. Many photographers are too quick to give up the lighting they currently use in favor of newer and more exciting ways of lighting a portrait. (See "Too Eager for Change?" above.)

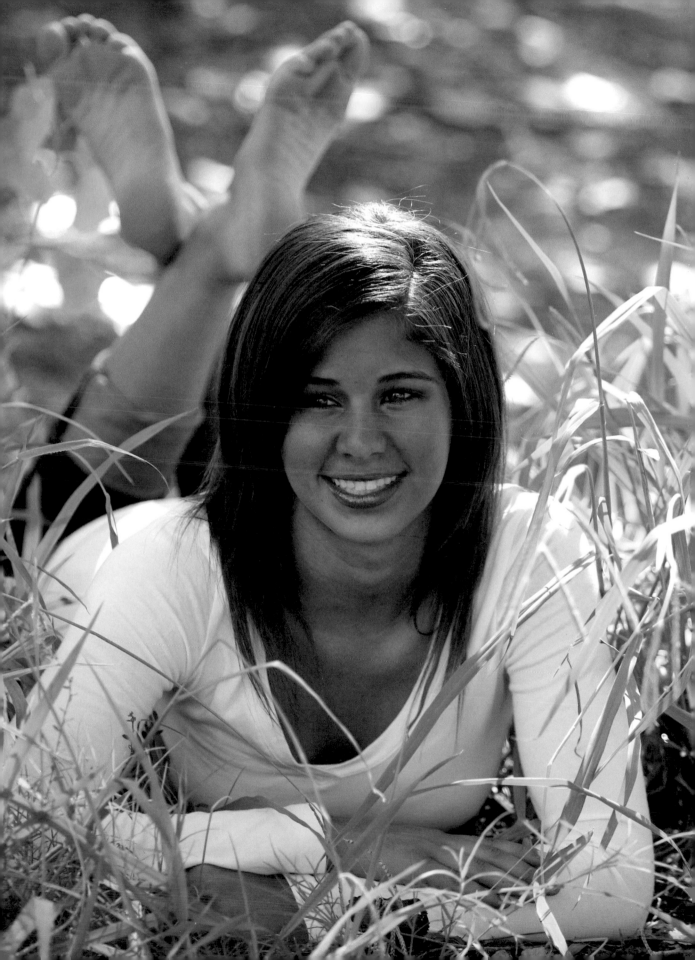

Calm Your Cluttered Mind

Talk to any successful person and they will tell you their greatest ideas have come to them when they were still and quiet. Great ideas tend to come to us when our minds are clear.

That begs a question: how many great ideas are you going to have if you are filling every second of your life with texting, Facebook, Twitter, video games, and television? Most people have become so accustomed to a high level of stimulation that they don't know what to do with themselves when they don't have at least a phone to keep them entertained.

Photographers pay good money to attend my workshops and seminars, but I always see at least a few sitting in their seats and playing with their phones. How crazy is it to pay good money to learn information that could change your business and your life, then miss out on it because you're so addicted to Pinterest that you just can't focus? How are great ideas supposed to come to you if there is no quiet time? You go from work to family to Facebook.

Visualization is the first step in creating portraits by design, rather than by default.

Before you e-mail me in complete disagreement, put your phone down for one day—take a 24-hour break. During this time, the only thing you can do with your phone is receive phone calls (just in case something important comes up). No texting, no Facebook, no *nothing* (and don't cheat by switching to your laptop). I think it is reasonable to say if you can't go one day without screen time, you might have a problem. By quieting your mind, you poise yourself to discover the greatness you have within.

Previsualization Is Key

Is a portrait created in the camera or in the mind of the photographer? I believe that portraits should be created in your mind before you ever pick up a camera. Too many photogra-

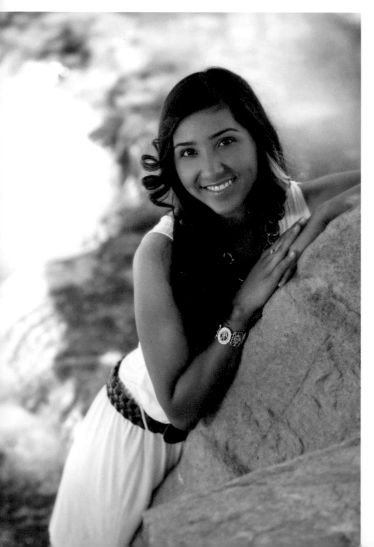

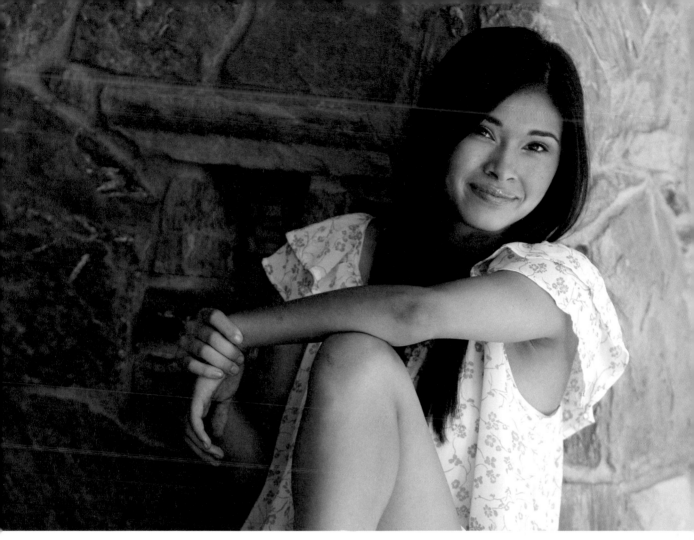

Above and facing page. When you quiet your mind, visualizing the images you want to create becomes much easier.

phers—and this goes for both seasoned pros and newbies—rely on the law of averages, taking way too many images in the hopes that something looks good. When a client tells you what they have in mind, you should be able to visualize exactly what your version of that image will look like and exactly what you'll need to do in order to produce the portrait that both you and the client have in mind.

Learn Not Just "How" but "Why"

Visualization is the first step in creating a portrait by *design*, rather than by *default*. This comes back to something I asked you to do in the previous section: look at images that impress you and try to figure out why the photographer made the decisions they did. Once you can figure out not just the *how* but the *why* in the decision-making process, you are on your way to mastery. Anyone can look at the catchlights in a subject's eyes and determine the relative positions of the light sources, but understanding *why* the photographer made those choices with that subject and that pose is the only way to create similar results.

5 The Bottom Line

In this book, I will mention money and profit quite often. I love photography, but I can break even staying home and watching television. I take pictures to earn a living. For most of my readers, this is a profession (or they want it to be), so making money is a necessity. As young photographers, we sometimes feel that photography is so much fun we'd do it for free . . . but then life has an ugly way of teaching us that we (and our families) need money to survive.

There is no "one way" to succeed in this profession. There are, however, some key factors that will help turn the odds in your favor.

Don't Let Ego Stand in Your Way

Some photographers decide that they can tell clients what is good. This usually lasts right up until the second or third time they are confronted by a client who asks, "What were you *thinking*, taking the portrait this way?" As the client leaves the studio (with their money still in their pocket), it suddenly becomes clear that there is a higher authority.

Creating the kinds of images that sell, the images that clients like, will take some focused practice. I am not saying that you should "sell out" (which is usually what young photographers say when I suggest they learn how to create portraits that clients will actually buy). However, if you want to consider only your own tastes, you should make photography your hobby, not your profession.

Understand *Your* Market

In business, what works well in one area doesn't necessarily work in another. There are differences in clients' tastes and beliefs, the popula-

Creating the kinds of images that clients like will take some focused practice.

tion of the city or town, as well as countless other factors to consider. I have tried many ideas during different stages of my business—things that seemed like a great idea when I learned them at a seminar but then flopped when I tried them at home. You can't rely on photographers who know nothing about *your* business or *your* potential clients to guide and direct your studio. Take in new ideas wherever you may find them, but then filter those concepts through your own experience, judgment, and knowledge.

Make Conscious Decisions

Take control of every aspect of your work and make conscious decisions based on what you need to do to create salable images. This includes your choice of equipment; your decisions about lighting, posing, clothing, and background selection; and the decisions you make about your business's marketing and appearance. If you analyze your unique market and make decisions designed to create the product that's best suited to it, you'll be amazed at the differ-

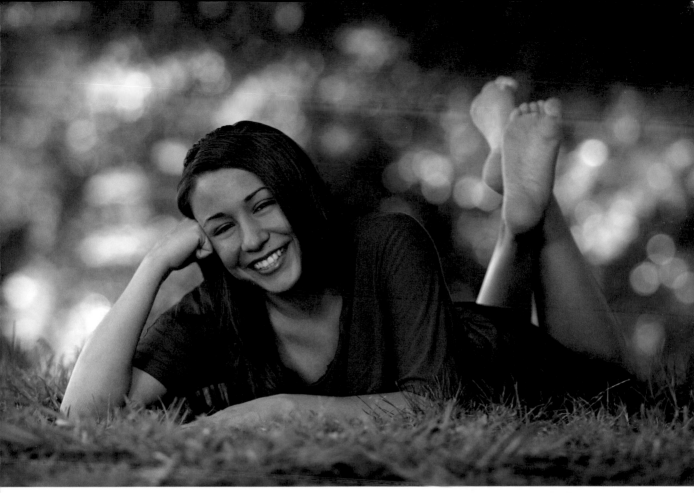

Don't spend your career struggling for each sale. If you learn to create what your clients want, the images will sell themselves.

ence it will make in your customers' satisfaction and your bottom line.

Develop a Style

Style is another important profitability factor. With an off-target style, you can struggle for each sale; with a well-conceived one, you can create images that sell themselves.

Many photographers spend their careers trying to convince clients to buy images that were created to suit *the photographer's* tastes, not to fulfill the client's expectations. Successful photographers determine what sells, then learn to enjoy and improve on that style.

Will You TRY or Will You DO?

I have prospered through many recessions and achieved almost everything I have set out to do for one reason: I don't try, I do. If you say you will try to do something, you will almost never succeed; it's a subtle way of convincing yourself that a task is beyond your ability. Instead, set a goal and say, "I will do it." Fully commit to accomplishing the task. If you are only going to try to be a successful professional photographer, put this book down and get a job. If you know you are going to be a great professional photographer, read on!

Don't Practice on Clients

The key to learning lighting is to test your setups and to practice using new ones. This should be done on your own time—not during paying sessions—and with friends, family, or other people who agree to pose for test sessions. When clients give you money to create portraits for them, they have a right to expect that you already know what you're doing; they're not paying for you to practice on them.

Practice with Real People

To get the most from your test sessions, photograph people who look like your paying clients, not like models.

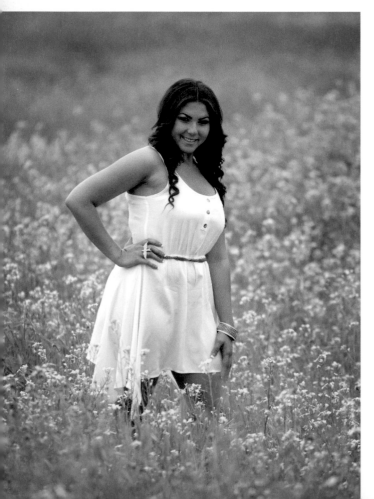

One reason many photographers become frustrated with outdoor lighting is that they practice only on perfect people. During these sessions, they produce decent images—but, to be honest, a first-year photography student can produce good portraits of perfect people.

A first-year photography student can produce perfect portraits of perfect people.

Here's the problem: one of these photographers shows his perfect-subject images to friends who, naturally, make comments about how talented he is. The feedback encourages him to start working with clients and charging for his services. Unfortunately, his first client doesn't look like a model—she is an overweight housewife who wants a sexy picture for her husband. Completely untrained and completely unready for a session like this, the young photographer blows it. Not surprisingly, the techniques that worked so well with a skinny model make the real woman look ridiculous.

Instead of accepting responsibility for the poor outcome, the photographer blames the woman for being overweight. When he talks to his photo buddies, he makes comments like,

Left and facing page. Most portrait clients aren't professional models. To make a living, you need to know how to make real people look great.

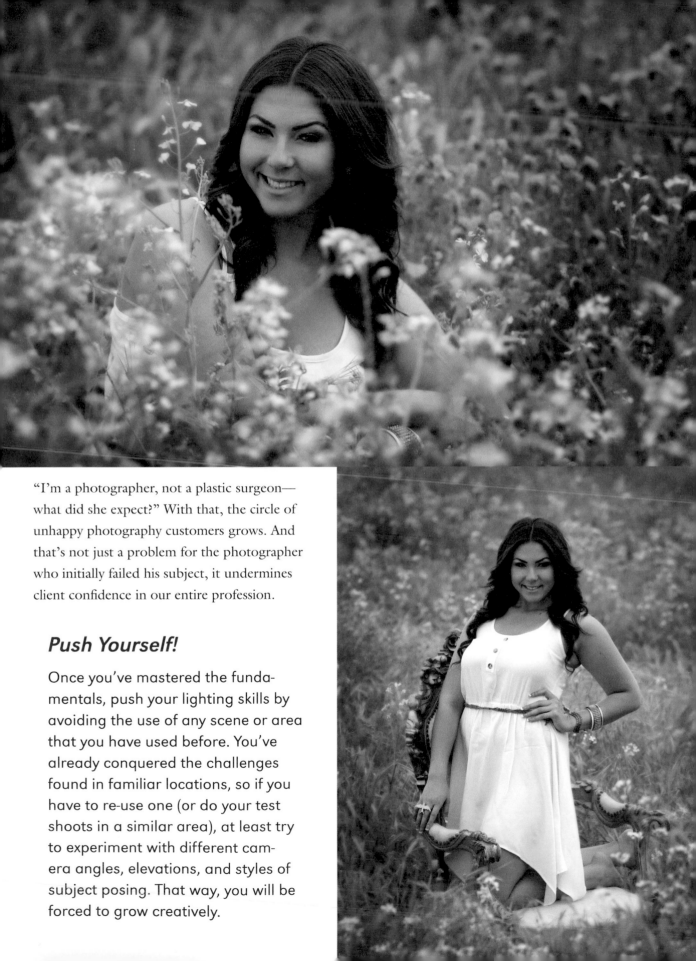

"I'm a photographer, not a plastic surgeon—what did she expect?" With that, the circle of unhappy photography customers grows. And that's not just a problem for the photographer who initially failed his subject, it undermines client confidence in our entire profession.

Push Yourself!

Once you've mastered the fundamentals, push your lighting skills by avoiding the use of any scene or area that you have used before. You've already conquered the challenges found in familiar locations, so if you have to re-use one (or do your test shoots in a similar area), at least try to experiment with different camera angles, elevations, and styles of subject posing. That way, you will be forced to grow creatively.

Unless you plan on giving your work away, you have to know what paying clients are looking for in a photograph. Then, you have to be able to create it in the camera. So what do the viewers—and more importantly the *buyers*—of portraits want to see?

1. Beautiful Eyes

In photography class, we are all taught that the first thing people look at in portraits is the subject's eyes. The eyes are the windows to the soul—but if they aren't lit and posed properly, the windows are closed.

Every source of light on a person's face produces reflections (catchlights) in the eyes. These reflections give life to the face. Know-ing that the eyes are the most important element in a portrait, I consider the eyes first when lighting any portrait.

2. Shape-Defining Shadows

Once you have lit the eyes properly, what is the next characteristic that paying clients are looking for? The answer is shadows. If you

> *You have to direct the viewer's attention to the subject's face.*

study fine paintings or photographs, you will notice that the illusion of depth we see

Catchlights bring the eyes to life—and that's a factor that is very important to paying clients.

Consider Contrast

In the left photo, the area of greatest contrast is the face, so it is the first place your eyes land. In the right image, the black shirt is the area of greatest contrast and steals attention from the subject's face.

in them is not produced by the *lightest* areas of the portrait but by the darkest. *Darkness* draws our eye to the light. Darkness gives a lifeless canvas the illusion of depth.

3. An Emphasis on the Face

A common misconception is that our eyes are drawn to the lightest area of a portrait. In fact, our eyes are drawn to contrast, not light. Look at the two images above, taken against a white studio background. In the first photograph, everything (including the young lady's hair) is white or near white; her tan skin then becomes the darkest area in the portrait, and that's where your eye is drawn. In the second photo, the same subject has a black shirt on. In this sea of white, the black shirt is the darkest area in the photograph—and that's where your eye is drawn.

Now, knowing that our eyes are drawn to contrast, where should the area of highest contrast be? Where do you want the viewer of an image to look first? The answer is the face.

What's Most Important?
This is so important that it bears repeating: **No matter what your portrait style is, you have to direct the viewer's attention to the subject's face.** Everything in a portrait should be selected to help achieve that end— and this includes the lighting and shadowing, the clothing, the posing, and the background.

Shadows create the illusion of depth in a two-dimensional image.

Emphasis on the Face

From head-and-shoulders images, to three-quarter-length shots, to full-length portraits, keeping the emphasis on the face is a key factor in designing portraits that will sell. This requires attention to every aspect of the image from posing and lighting to background and clothing selection.

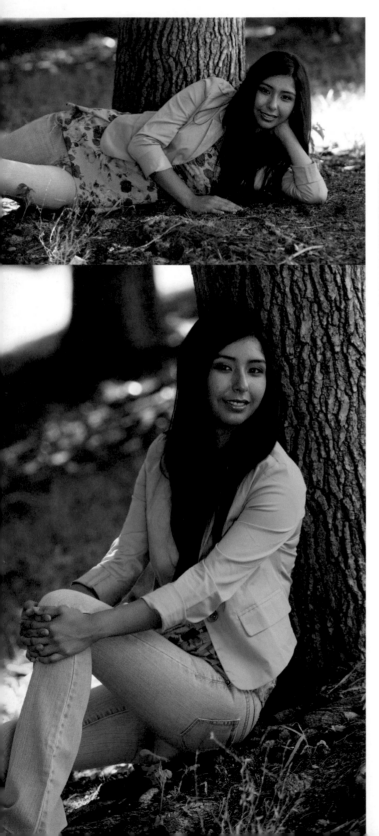

Learning lighting requires understanding not just how to produce different styles of lighting but also how to use each style of lighting. The lighting needs to coordinate with everything else in the frame to produce a cohesive look and style.

Is It Right for the Client?

Every lighting style you learn (or already know) will have situations for which it's perfect and situations for which it's completely wrong. You have to know how to choose the right style of lighting for the result the client desires.

Consider the Subject

Sometimes, the essence of the subject will tip you off to a good choice. For example, if an elderly lady comes in to take a portrait for her children, the scenario immediately rules out something like fashion lighting. It just wouldn't make a lot of sense. Chances are something soft and more traditional will better fit the bill.

Conversely, if your client is an aspiring model who wants head shots for her portfolio, it's traditional portrait lighting that would look out of place; you don't want these images to look like portraits for her grandmother's mantelpiece.

Consider the Purpose

Just evaluating the subject is not enough; you also need to identify the reason the client wants the portrait taken. If a young woman says she

Right and facing page. To create an image that will sell, the lighting must harmonize with the client's purpose for the portrait (along with the pose, location, selection, clothing selection, etc.). Compare the casual images on the facing page with the more glamorous portrait to the right.

wants a portrait of herself, you'll be shooting in the dark unless you ask about the purpose of the portrait. She might want a portrait for her business, her boyfriend, or her grandparents.

You have to choose the right style of lighting for the results the client desires.

Even when the client defines the purpose of the portrait, you should verify that you're both on the same page. Here's another example: A woman calls you and says she wants a "sexy" portrait for her husband. Do you have the images in your mind? Good. Now, when she gets to the studio, you find out her husband is a minister. Are any of the images you previsualized appropriate? Adjectives like sexy, happy, natural, and wholesome all represent different things to different people. Before you decide how to depict someone, you had better understand what these things mean to them.

Understand What They Want

The key is to understand what your client wants *before* you try to give it to them, then make sure the looks you create are appropriate. A portrait for a parent should be much different than a portrait for a romantic interest. A business portrait should have a different look than a portrait showing the person in her "off-duty" hours.

I've already hinted at one obstacle photographers face when booking location sessions: the time involved. This often leads them to raise their prices for location sessions to a point where no one books them. That's not a good solution.

Multiple Clients

So if you can't charge a lot, and the time commitment (driving to and from shoots, setting up, etc.) is fixed, what's the answer? Our solution is to increase the productivity of each outdoor session by working with multiple clients.

Experienced photographers know how to make midday light work for them.

To offer sessions without upcharges for travel and setup time, we schedule blocks of appointments on certain days at certain locations. Because of the size of my business, that means devoting full days to outdoor sessions. If you do a smaller volume of work, you can schedule three or four sessions in a morning or afternoon.

A Variety of Locations

We offer outdoor locations for spring and summer sessions, as well as indoor locations for winter sessions. We select some locations that are for casual portraits (typically park scenes) and some that are for more elegant styles of portraiture (typically upscale architectural scenes). If a client wants to go to their home or some other location that is special to them, we schedule these appointments before or after my studio sessions. This way, any driving I have to do is on my way in to the studio or on my way home. Naturally, the clients do pay a higher sitting fee for the use of a personalized location, which covers the additional driving, setup, etc.

Booking this way ensures average clients will actually decide to do outdoor sessions—and these portraits typically generate *significantly larger* sales than studio sessions. It also lets us advertise that, unlike others in our market, we offer outdoor portraits at no extra charge.

Challenges

While I will not claim that this approach is without its challenges, the profitability of these sessions makes them well worth the added effort.

Planning. Think ahead to the area where you will be shooting and let clients know what types of clothing will look best. When they arrive at the shoot, they should be dressed in their first look. For subsequent looks/locations, photograph one client while the others are changing.

Logistics. Photographers waste a lot of time waiting at outdoor sessions. Once you have decided how to shoot a scene, how long does it take to shoot a few poses? If you set up and then sequentially photograph several people in the same lighting/scene, you'll spend more of your

Short Wait? No Problem.

Think about how many times you've waited a few minutes to be seated at a restaurant or to see your doctor. It just seems normal when doing business with a popular professional or business. (Don't allow the waiting client to watch the session you're shooting, though; it can unnerve the person being photographed.)

time behind the camera. Clients may have to wait a few minutes to start shooting after they finish changing, but that doesn't affect your profit.

Lighting. About 95 percent of my outdoor portraits are taken between 10AM and 5PM. These are not the hours photographers consider "ideal" for portrait lighting—but they are the hours clients consider ideal for a portrait session. Fortunately, experienced photographers know many ways to make midday light work for them. Understanding these lighting approaches is critical to making outdoor portraiture a profitable part of your business.

Right and facing page. Photographing multiple sessions throughout the day is the key to making outdoor portraiture a profitable part of your business.

As a businessperson, there are many factors to consider when you start offering outdoor portraits and selecting the locations you will use. Some of these are aesthetic, but others have to do with the experience you give your clients.

Safety

Safety is the first concern. While urban scenes make for some interesting location photography, in some cities these locations can put you and your clients at risk. Even public parks in questionable neighborhoods can pose undue risk. Ask yourself: Is it is worth losing your equipment, your business (if your client should get hurt), or even your life to create a portrait?

Get Client Input

For our studio sessions, we have clients look through sample books and pick out some images they like before we start their session. This gives me some direction and helps to ensure they'll like their images. Since we don't have a lobby for outdoor sessions, I encourage seniors to visit our web site and print out some of the outdoor ideas they like the best, then bring them to the session. (It is important that your web site and studio displays show only the locations and areas you currently offer. Outdated images should be removed.)

I also explain that certain areas are not available at certain times of day. I don't want a senior to be upset because we can't do her favorite scene at the time she chose for her session.

Instead, look for parks, outdoor locations, and interior settings that are in the finest part of your town. This is where your clients are safe. In

A beautiful image should be more than a shot in the dark.

addition, this will create a better impression of your business. You'll probably find that these are the areas that most of your clients come from anyway, so they are usually very convenient.

Work with an Assistant

Don't work on location without an assistant. Especially with opposite-sex seniors, working in remote locations without an assistant and a parent present is asking for trouble. Even an unsubstantiated allegation is enough to ruin a successful business. Why take that chance?

I work with one or two assistants and insist that a parent accompany the senior throughout the session. I don't care if Mom reads a book under a shady tree, as long as she is nearby. Insisting that a parent accompany the senior shows our professionalism. Additionally, if a young lady needs help with a zipper, I want Mom there; I don't always have a female assistant.

Provide a Changing Area

You need to provide a comfortable space for your clients to change their clothing. We have a

changing tent, which is very convenient. We also bring an ice chest with cold water and sodas, as well as wet wipes, hair spray, hair pins, and disposable combs.

Some photographers use public rest rooms for this purpose, but these facilities are often dirty and unpleasant. Additionally, they are *public*, so anyone could be in them. I never thought about this until a ring of male prostitutes was arrested working out of one of the public-park rest rooms in my area. Does this seem like a place you'd what to send a seventeen-year-old high-school senior? I don't think so!

Prepare Your Clients

Clients get my cell-phone number so they can reach me in case they are lost or running late. They also receive a map to the location, along

with driving directions from the north, south, east, and west. Additionally, our web site provides complete information about the locations we usually go to, along with directions to each.

What Should They Wear?

We give our clients the typical guidelines on what colors of clothing to avoid, the best styles of clothing for photography, and colors of clothing to wear in order to conceal problems such as wide hips and not-so-flat stomachs. A streaming consultation video also explains makeup, jewelry, other accessories/props, and the coordination of clothing for portraits that involve more than one subject. Very little is left to chance in ensuring that every element of the portrait makes sense visually. After all, a beautiful image should be more than a shot in the dark.

Having clients select some images they like from your portfolio provides direction for the session.

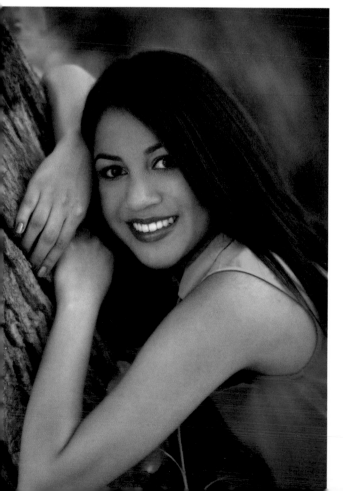

Background Selection

When I select a background, I am looking for much more than lighting and the basic coordination between the background and the client's clothing. I am looking at the overall feeling that a scene or background portrays, which is determined by the predominant lines and textures. Each line and each texture will affect the feeling the viewer gets when looking at the portrait.

Including foreground elements enhances the sense of depth in the portrait.

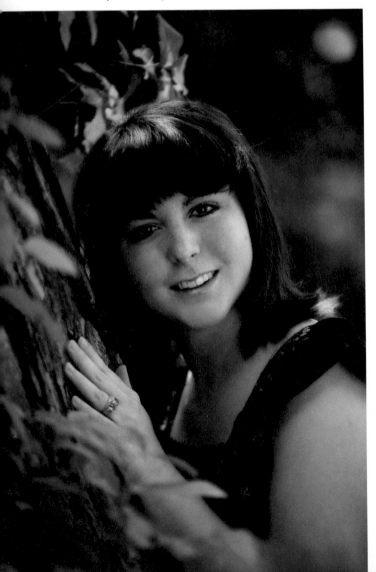

How Can You Create Depth?

There are two simple ways to increase depth in any portrait.

1. **Subject Placement.** Most photographers place the subject in a clearing with the background behind them. Instead, I suggest putting the subject in the middle of the "background" area. This way, you have a foreground as well as a background. A foreground is the missing element in most studio and outdoor portraits.
2. **Location Selection.** The second way to increase depth in a portrait is to look for a posing area that is at least twenty to thirty feet from the background. I often shoot from one grove of trees to another or find a patio, path, bridge, or fence/walkway to pose on. This puts more distance between the subject and the background. When there is nothing to use as a foreground at a greater distance, you can use a larger telephoto lens to throw the background further out of focus.

I also look to give my portraits as much depth as possible. This is done by avoiding what most photographers do: placing the subject against a tree with a background a few feet behind them. If that's all you want, you could just as easily take the shot in or around your studio.

In my outdoor portraits, I want to have at least two points of focus in front of the subject and at least three points of focus behind the subject. Close-ups need fewer foreground and

background points of focus, while a scenic full-length portrait may need more. My goal is to have the foreground lead your eye to the subject and the background lead your eye further and further into the background.

Setting Up the Lighting

While the vast majority of scenes are lacking in some way and need correction to provide a professional-quality portrait, there are some locations that don't require any additional lighting. These scenes are like professional models—they are so perfect that any photo student could produce a beautiful portrait just by capturing what is there. If you happen onto one of these "perfect scenes," count your lucky stars and take advantage of the opportunity!

When I go to an outdoor location, I set up my lighting for all of the different areas that I will be using for that time of day. Normally, I set up a natural light area; an outdoor photo booth (see lesson 32) for backlit, waist-up images; and one or two areas for full-length portraits created using flash.

As the light of the day shifts, I change locations and modify the lighting.

As the light of the day shifts, I change my locations and modify the lighting—but I can often photograph two, three, or even four sessions without changing the basic locations I first selected for the portraits. This lets me go from area to area quickly, without having to set up my lights and equipment over and over again.

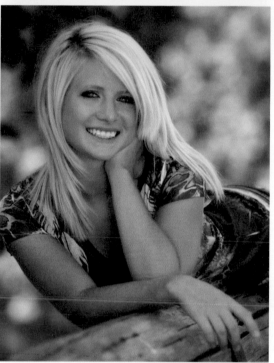

Full-Length Portraits

Photographers tend to like creating full-length portraits, and most of our senior portrait clients want to shoot these poses, too—they always like to show off their new outfit, shoes, painted toenails, or fit physique. However, the portraits that clients actually *purchase* are typically composed closer and have a larger facial size than a full-length provides. Therefore, we take an additional close-up shot of every full-length pose (as seen above). Since we started doing this, our sales have grown dramatically—and the number of people who want to "retake" poses or who have issues with the photographs from a session have been greatly reduced.

Before we start into the techniques used for modifying and controlling lighting outdoors, there are some basic pieces of equipment and working techniques that will make your life on location a lot easier.

One Assistant or Two

When I go out for a full day of location shooting and have two assistants to help, I'll bring along the full range of equipment described below.

Below and facing page. Backup gear is a must. Cancelling due to a malfunction is not only unprofessional, it's a waste of time and money.

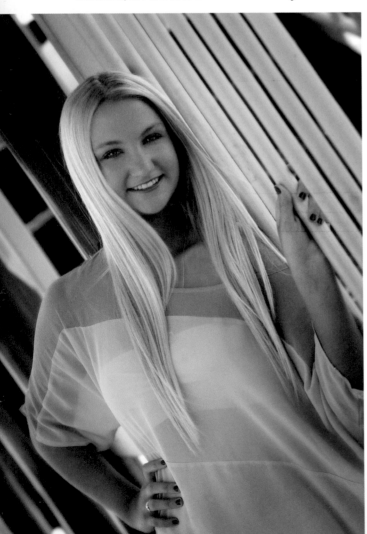

If I go to a location for fewer sessions or only have one person helping me, I narrow down the lighting equipment to the bare bones, bringing just the core pieces of the studio lighting system and a few reflectors and black panels.

Tripod

Outdoors, you often work with slower shutter speeds than in the studio, so it's important to ensure there is no camera movement. This makes having a heavy-duty tripod a must. The legs of your tripod also need to be easily adjustable, since you will often be working on uneven terrain. I frequently find myself shooting from the bank of a creek or the side of a hill—places where the legs of my tripod are set at three different lengths to level the camera.

Backup Gear

Since I go to outdoor locations that are a significant distance from my studio, I take at least one backup piece of equipment for everything I will need. I also take many sets of charged batteries for the camera and to power my flash units. Additionally, I take at least two AC/DC converters to power my laptop for downloading images, and more memory cards than I will use. With digital, everything needs power, so packing properly becomes a must.

Lenses

You will need a variety of focal lengths to get the shot you want, so a selection of prime lenses

(or a zoom lens that covers a wide range of focal lengths) is required.

Imagine you want to take a head-and-shoulders pose. While the light level on the background makes it usable, the shapes or textures are very distracting. One solution would be to pull the subject away from the background, throwing it further out of focus. In many situations, however, the setting won't physically allow that. In that case, the best solution would be to select a longer telephoto and open up to a larger aperture to soften the distracting background.

I take at least one backup piece of equipment for everything I will need.

You will also find yourself working in cramped situations where a wide-angle lens is the only way to get the shot you need.

The only focal length I never use is what is considered a "normal" lens for your format of camera. Clients don't pay professional prices for a portrait that is "normal." Most of my portraits are taken using the traditional "portrait lens" focal lengths, in the 135–150mm range.

Lighting Equipment

I tend to pack much more lighting equipment than I actually need, but I use many different styles of lighting when shooting outdoors and I want to be prepared. I have a variety of white and silver reflectors in different sizes, many large black panels, and mirrors of different sizes. I also carry translucent panels, studio flash units, batteries for them, larger light modifiers for the

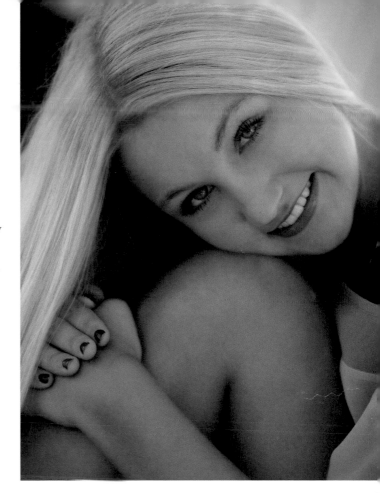

flash units, wireless slaves, large light stands, weights, and grips.

Additional Supplies

I also take a changing tent, plus a toolbox containing everything from sync adapters and cords (just in case the wireless goes out) to safety pins, tissues, and hair spray.

Brands Don't Matter

You'll notice that I didn't mention brands. Professional photography is about what you know, not the brand you use. Canon or Nikon, Mac or PC—it has nothing to do with the final products you create. If someone tells you differently, you can almost bet they are sponsored by the company whose equipment they are recommending.

File Format

In the studio, I prefer to capture everything in the JPEG format for easy downloading and storage. Our clients preview their studio images immediately after the session, so this is the only format that works effectively.

Outdoors, I shoot in the RAW mode. Shooting JPEGs requires strict color and exposure controls. While this is possible in the studio, on location it would be impractical; the session would be more about exposure and color temperature than working with the subject. Shooting in the RAW mode gives us quite a lot of wiggle room—critical when doing multiple sessions in an uncontrolled environment.

White Balance

To ensure that all the images from a location session match, we create a custom white balance. This works better than using the automatic white balance. After the camera is white balanced to the scene, we make the first shot with a white/gray balance card in the frame. The white area ensures the image isn't overexposed;

A quick shot with a white/gray balance card ensures a good color balance and exposure.

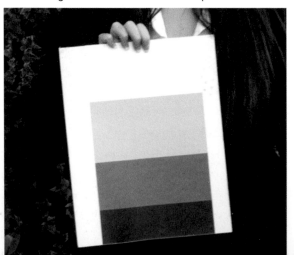

Previsualization *Again?*
Let's hear it one more time: **portraits must be created in the mind before the camera is picked up.** You have to know what you're trying to achieve before you can select the camera settings needed to create it.

it would be immediately flagged in the viewfinder if it were. The gray area is a color-balance backup; should the custom white balance not eliminate any color cast, it's a quick task in post-production to balance one image to this neutral gray area, then apply the same conversion to the other images of the same scene.

Aperture

When photographers ask me about aperture settings, I find they are often hoping I'll reveal some magical f-stop that will make their portraits look like mine. That doesn't exist. Like every other factor in the portrait design process, the aperture setting is something about which you have to make a choice based on what is required to produce the image you have previsualized.

The f-stop you choose does have a huge impact on the final image, but that's because it controls the depth of field. The current trend is to use a very shallow depth of field. As a result, many photographers opt for telephoto lenses with very large apertures (f/1.2, f/1.8, f/2.8, etc.). The combined effect of the focal length and wide aperture is a razor-thin band of focus that throws the background totally out of focus.

For some images, a shallow depth of field (top) creates the perfect look. For other scenes (bottom), great depth of field more effectively sets the scene.

At midday, many backgrounds have sunspots or contrasty lighting, so I do tend to shoot with my 70–200mm f/2.8 lens wide open, blurring the background as much as possible. Even street scenes can become salable portraits when the elements in the background and foreground are sufficiently diffused.

Shooting in the RAW mode gives us quite a lot of wiggle room . . .

However, a shallow depth of field isn't something I *always* use. I determine my aperture setting based on how much of the foreground/background I want in focus, not because I want to follow a trend. There are many times when the background or foreground needs some sharpness to enhance the portrait or to reveal whatever story I am telling. At these times, I stop down the lens to bring the needed background/foreground elements into focus.

Complete Control

One of the nice things about portraiture is that you have complete control over your images. Contrast this with the challenge of shooting candid events (like weddings or sporting events) where time is limited and moments are fleeting. As a portrait photographer, you can fully realize your creative vision—and you'd be crazy not to exploit every control to its fullest!

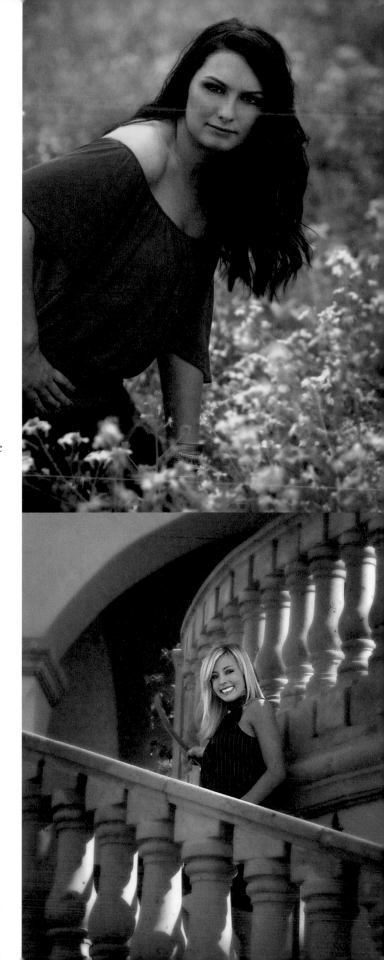

When creating studio portraits, we concern ourselves with a wide variety of light functions. As we move to the outdoor environment, the number of sources we'll typically consider will shrink, but producing and controlling them will become somewhat more complex.

Main Light

Just as in the studio, the main light is what creates the pattern of light and shadow on the subject's face. It is also the light that illuminates

The main light, here from camera right, shapes the portrait subject's face and produces the catchlights that bring the eyes to life.

the subject's eyes (in lesson 7, we looked at how important this is to the final sale).

If you can't move the light source, you have to move the subject.

Unlike in the studio, outdoor photographers often use the natural light as the main light source. Since you can't move the sunlight in relation to the subject, this means that you'll have to move the subject in relationship to the sunlight in order to create the lighting pattern you want. Of course, when you move your subject relative to the sunlight, you may also be moving them relative to the desired background. This is part of why location selection is so important. (The same principle applies whether the sunlight is directly from the sky, streaming in under the edge of a porch, or bounced off a building in your scene. If you can't move the light source, you have to move the subject.)

In some cases, such as when overpowering the sunlight with flash, the main light position is something you will be able to control. In that case, the approach to positioning the light is the same as in the studio: watch for catchlights and face-contouring shadows in the desired position.

Fill Light

Depending on the direction and quality of the light (see lessons 16–18), it may be necessary

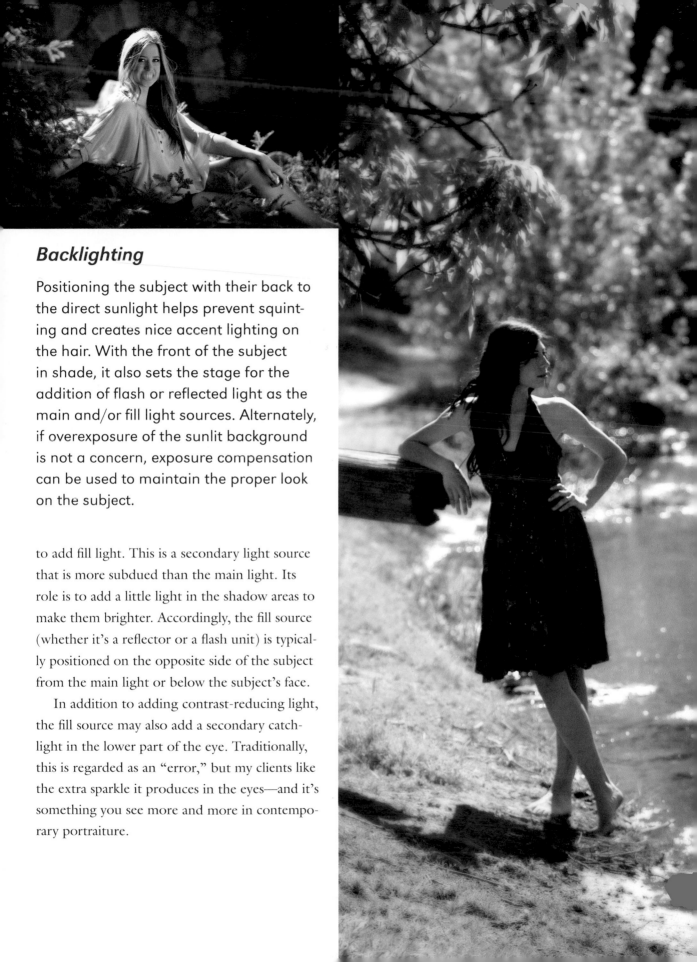

Backlighting

Positioning the subject with their back to the direct sunlight helps prevent squinting and creates nice accent lighting on the hair. With the front of the subject in shade, it also sets the stage for the addition of flash or reflected light as the main and/or fill light sources. Alternately, if overexposure of the sunlit background is not a concern, exposure compensation can be used to maintain the proper look on the subject.

to add fill light. This is a secondary light source that is more subdued than the main light. Its role is to add a little light in the shadow areas to make them brighter. Accordingly, the fill source (whether it's a reflector or a flash unit) is typically positioned on the opposite side of the subject from the main light or below the subject's face.

In addition to adding contrast-reducing light, the fill source may also add a secondary catchlight in the lower part of the eye. Traditionally, this is regarded as an "error," but my clients like the extra sparkle it produces in the eyes—and it's something you see more and more in contemporary portraiture.

In the studio, light is about control and placement. Dealing with natural light outdoors requires "seeing."

Find the Right Light

Certain scenes and times of the day create more easily usable light for portraiture than others—but if you understand what is producing the light, its direction, quality, and the quantity of the light that will be acting as your main light

Below and facing page. Two looks with the subject in the same position relative to the light.

What About Midday?

We were all taught that the best outdoor light occurs right after sunrise and just before sunset. While this light is certainly ideal, it only lasts 30 to 45 minutes, which is barely enough time for one session. If you have to travel to the location, set up, shoot for half an hour, then tear down and drive home, you'll have to charge so much that very few clients will book these sessions.

Therefore, the key to success in location photography is learning to control and manipulate the natural light as it changes throughout the day. Whether you are a wedding photographer shooting an all-day event or a portrait photographer trying to work around the schedule of a busy family, sooner or later you will find yourself photographing outdoors at high noon and you had better know how to produce a professional-quality portrait using the existing light.

source, you're well on your way to making just about *any* light usable.

The light in your scene may come from the open sky or it might be the sunlight reflecting off of a nearby building. While both of these sources create usable light, you must be aware that the differences in contrast, angle, and amount of light from the two light sources will provide a different look in the final portrait

Two Approaches

There are two strategies that photographers use for lighting portraits outdoors. While both have

the potential to produce professional results, neither one provides a complete solution, most often, we will need to call on both approaches during any given session.

1. **Use the Natural Light As-Is.** The first strategy is to use only natural light, looking for the best light that a scene can provide and then working with it. Photographers who take this approach either shoot very few sessions (because they tend to work only at those perfect times of the day when the lighting is ideal) or shoot images with little variety because they are forced to use the same good locations over and over again. Think of the thousands of outdoor portraits you've probably seen with the subject leaning against a tree—one of the few safe spots if you rely solely on natural light during midday hours.

2. **Augment or Overpower the Natural Light.** The second approach is to modify the light, finding a scene and then adjusting the light to make that scene work. Photographers who use this approach tend to use flash or reflectors to overpower any natural light and achieve a consistent result. The problem is, these photographs tend to look unnatural and often lack the lighting qualities that should be evident in a professional portrait. You see this type of work from many wedding photographers who use their on-camera flash in order to work quickly during a hectic wedding.

There are obvious problems to both approaches—and all of them stem from a failure to understand natural light and the best ways to control it. It's a problem I struggled with myself. When

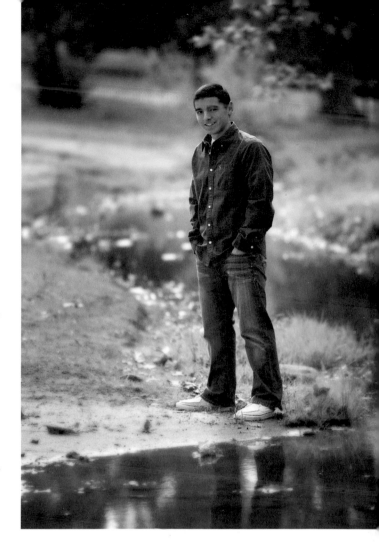

I first started photographing outdoors, I quickly realized that producing a professional-quality, salable image was much more difficult on location than inside the studio.

Sooner or later you will find yourself photographing outdoors at high noon.

So, let's start with the natural light on its own. Then we'll look at ways to modify it. Finally, we'll consider approaches for augmenting or overpowering it.

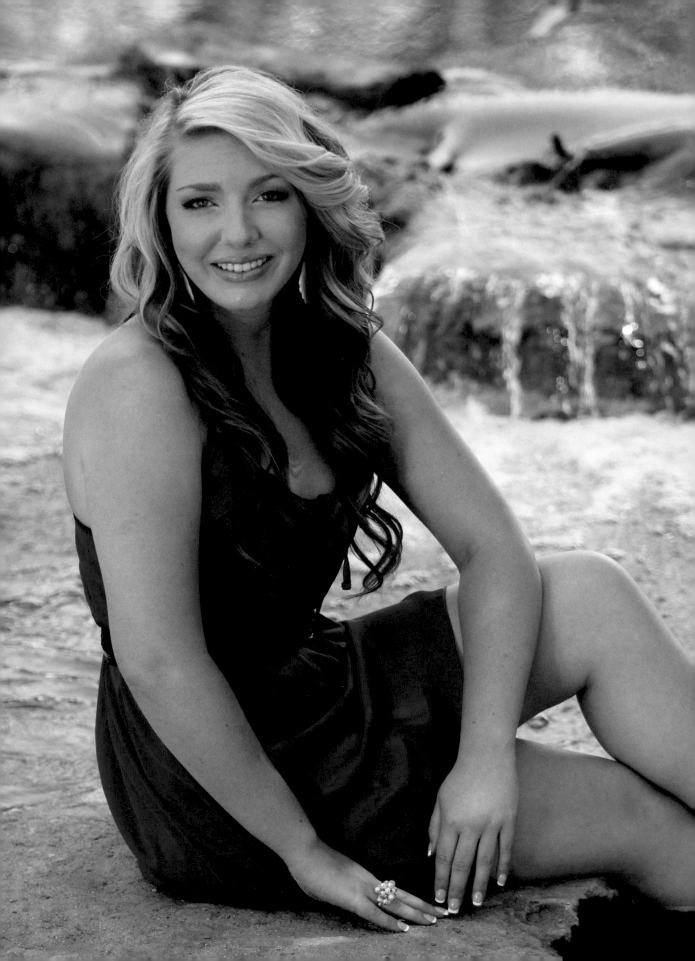

Direction of the Light

The direction of light is easy to determine: stand at the subject's position, then face the camera. If you see nothing behind the camera but blue sky, your lighting will have no direction. This would be the same as bouncing light off a plain white reflector above the camera in the studio; it's great for fill, but it's not a usable main-light source because it lacks direction.

Now, let's say you turn around and you are facing a huge grove of trees or tall buildings blocking that blue sky from view. You still have no light direction, but you have found your source of shadow.

For light to have direction, there must be a light source *and* a shadow source. In the studio, you're working in a dark room, so there's plenty of shadow. Outdoors, the opposite is often true;

Below and facing page. Changing the position of the subject's face relative to the light changes the shadow formation.

there's so much light that it looks directionless and flat. To create a shadow, we need to keep some of the light from hitting the subject. (We'll look at how to do this in lessons 30–32.)

For light to have direction, there must be a light source and a shadow source.

Lighting Directions to Avoid

Light from behind or from either side of the subject can create a nice look. What you want to avoid is light from directly overhead (which tends to cast shadows across the all-important eyes) or directly in front of the subject (which results in the flat look described at the start of this lesson).

Angle of the Light

The angle from which the main light strikes the subject controls the placement of the shadows on their face. This contouring in critical to the look of the final portrait. If it doesn't look right, change the position of the light or the subject relative to it.

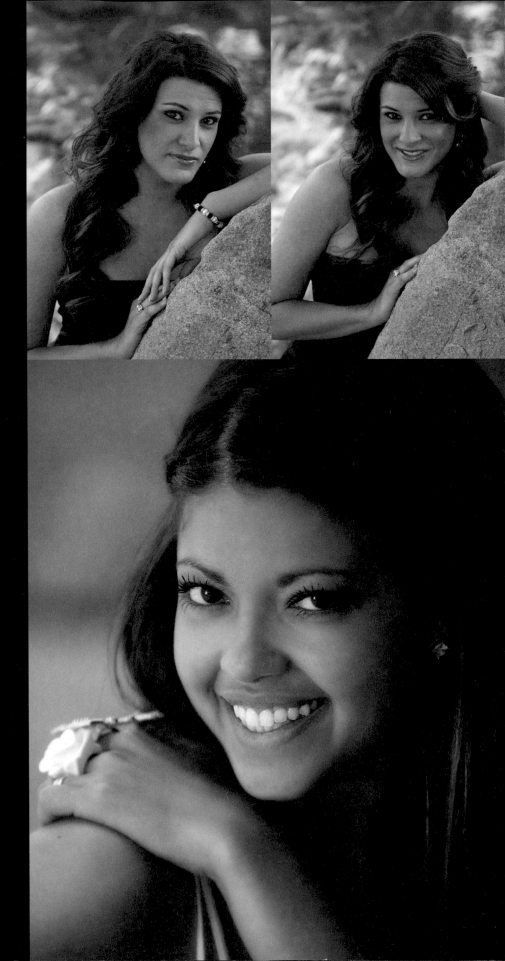

There are two basic scenarios for using directional light, which is good for revealing the contours of the face. These are broad lighting and short lighting. The shape of the individual's face will often suggest which is the most flattering choice. For both looks, the subject's face is turned at least a little away from the camera, making one side of the face more visible than the other. This is the most flattering way to photograph most portrait clients.

Broad Lighting

To produce broad lighting with ambient light, the subject is positioned so that the light falls on the side of their face that is more visible to the camera (the "broad" side of the face). If lighting with flash, the main light is positioned to create the same effect. Because broad lighting places highlights on a large part of the face, it's a good option for subjects with normal to narrow faces.

In broad lighting (below), the main light falls on the side of the face that is more visible to the camera.

In short lighting (all images on this page), the main light falls on the side of the face that is less visible to the camera.

Short Lighting

To produce short lighting with ambient light, the subject is positioned so that the light falls on the side of their face that is less visible to the camera (the "short" side of the face). If lighting with flash, the main light is positioned to create the same effect. Because short lighting places highlights on a narrow part of the face, it's a good option for normal to wide faces.

Other Considerations

Short lighting tends to be popular for many face shapes and sizes, since almost everyone appreciates a slimmer look. Creatively, you may opt for broad lighting to communicate a more open, friendly look. Short lighting, on the other hand, tends to create a look that is more dramatic.

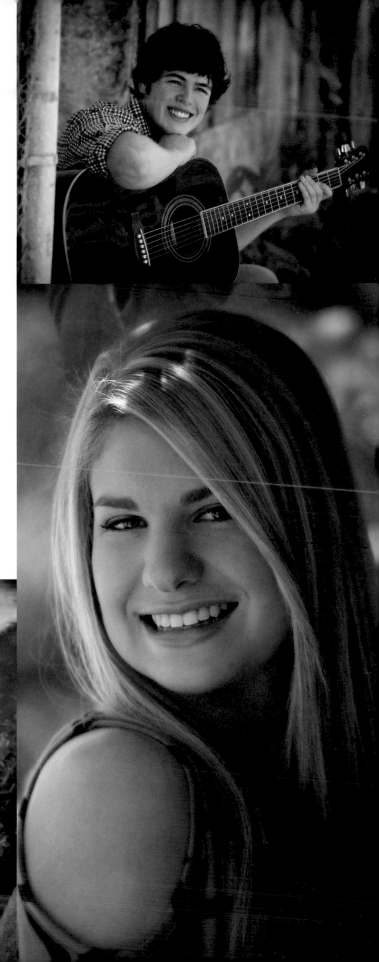

Short Lighting

Short lighting is a good lighting choice for a high percentage of my clients. Its slimming effect on the face is something most people appreciate.

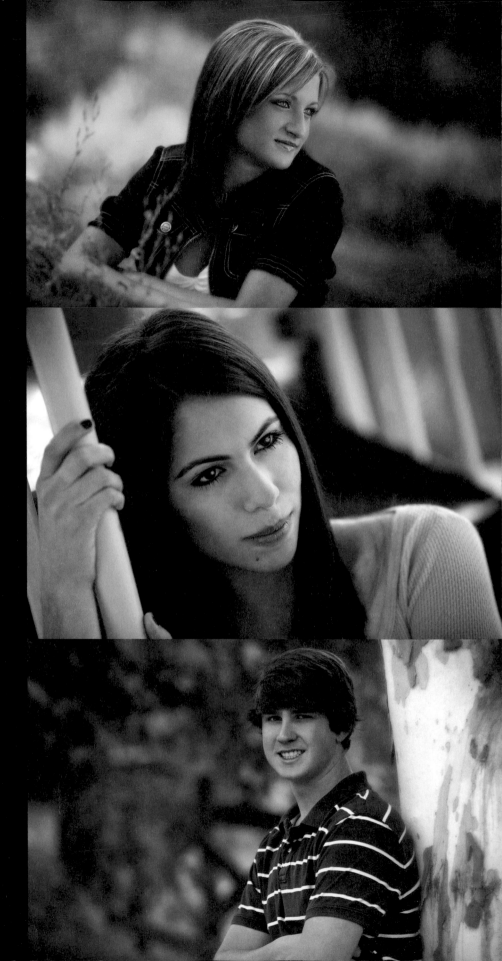

46

Broad Lighting

Broad lighting creates an open, appealing impression of the subject. However, it tends to widen the look of the face, so it's best reserved for subjects with average to narrow face shapes.

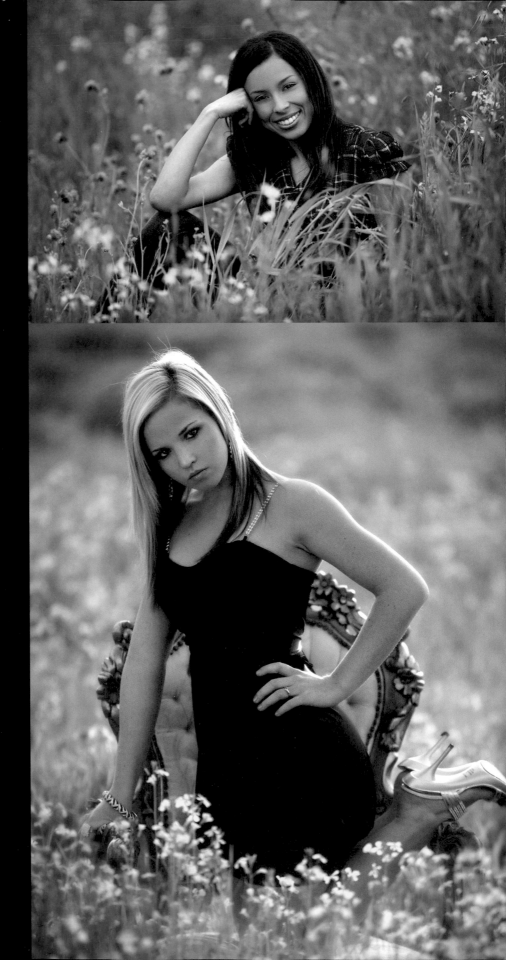

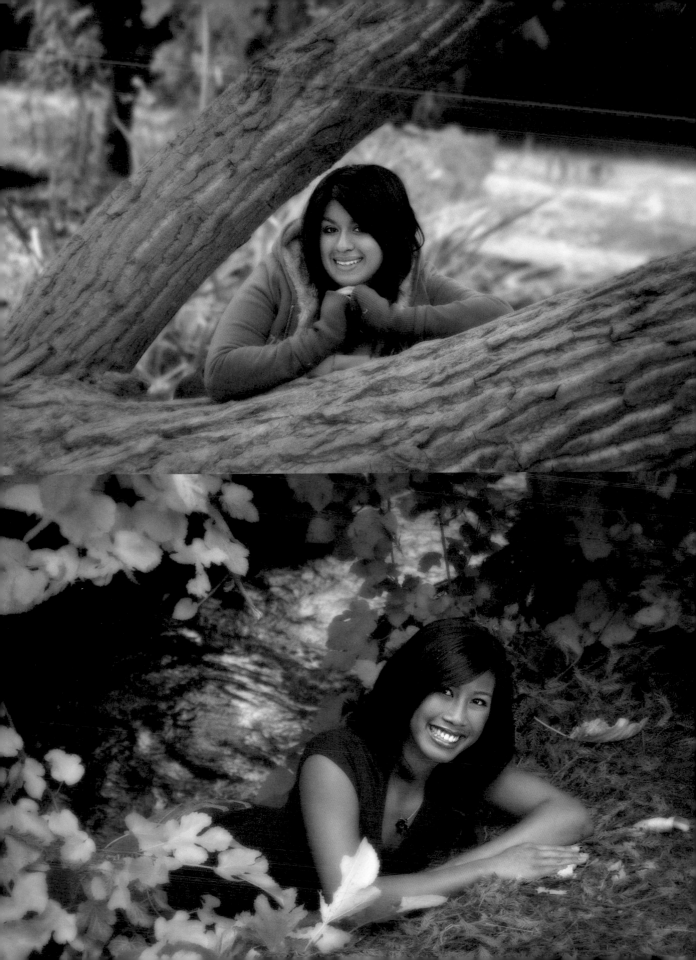

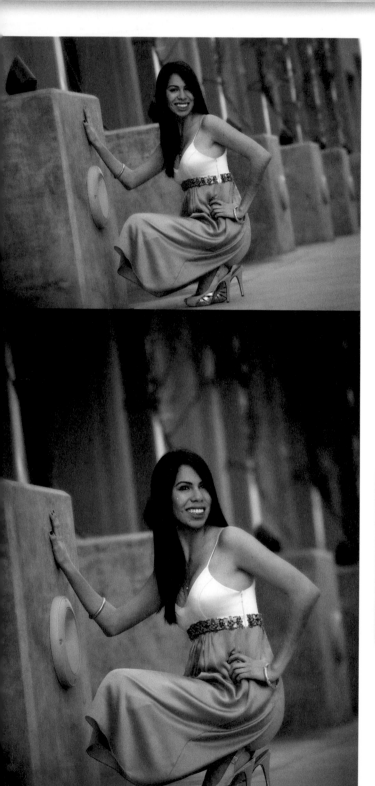

Highlight to Shadow Transition

The transition zone of a portrait, the area from the darkest part of the shadow to the start of the highlights, is the key difference between an average photograph and a beautiful portrait.

1. **Narrow Transition = Hard.** When the transition zone is narrow, the lighting is described as hard. This lighting is good for emphasizing textures—which can be great for bringing out the embroidered details on a wedding gown, but not so great when it emphasizes every wrinkle and blemish on your subject's face.

2. **Broad Transition = Soft.** When the transition zone is broad, the lighting is described as soft. Soft light is more forgiving; it does not bring out imperfections in the skin and face (but it can also obscure textures that you might want to capture).

Snapshot or Pro Portrait?

In general, the wider the transition area, the more depth and realism your portraits will have. Often, control of this factor is what separates outdoor "snapshots" from professional outdoor portraits that clients will actually buy. However, as shown on the facing page, the look of hard lighting can be nice in certain circumstances.

When the transition between the highlight and shadow areas is broad and gradual, the light is described as soft. Soft light is created by sources that are large relative to the subject.

When the transition between the highlight and shadow areas is abrupt and well-defined, the light is described as hard. Hard light is created by sources that are small relative to the subject.

Take Control

The size of the transition zone is controlled by the size of the light source relative to the subject. Small sources produce sharp transitions, while large sources yield softer looks.

Imagine you are in the studio and using a spotlight for your first few shots. Then, you switch to a softbox as your main-light source for the subsequent shots. Both sources will provide usable light, but the characteristics will be different. Which is better will depend on the look you want to create.

The same is true with natural light sources. Let's say you go into a client's home, where you find windows of many different sizes. For your first shot, you choose a very large window for your main light. This source would provide light with very soft characteristics. It would be perfect for a soft, dream-like photograph. The second location you choose in the house has a smaller window. Would that change the characteristics of the light? Of course it would. The light would be harder, with more well-defined shadows.

The transition zone is controlled by the size of the light relative to the subject.

The same principles apply to lighting at a park. Light provided by a large area of open sky provides very soft lighting. If the scene has obstructions that reduce the size of the open sky relative to the subject (just like the smaller window) the light will have a slightly harder characteristic.

An important (but often overlooked) consideration you need to make when designing your outdoor lighting setup is how much time you want to spend enhancing the images you take.

Watch the Shadowing

While you probably don't want to use exclusively ultra-soft, shadowless lighting to deal with the imperfections of the face (because simple retouching has to be done anyway and takes very little time), harder lighting and insufficient fill can create excessive shadowing that must be dealt with in postproduction. More on this in section 24.

Time Is Money

Today, thanks to digital capture and Photoshop, it's all too common to see the computer being used to fix the mistakes of the photog-

Transformations

Back in the days of film, there was a photographer here in California who was known for his elegant, nearly life-size portraits—and the amount he charged for them. I was taking a tour of a large photo lab when the guide stopped and explained that a particular stack of work belonged to this prestigious photographer. The large canvas prints (with only negative retouching) looked incredibly rough and had very heavy shadowing on the side of the nose, the shadow-side eye socket, and the side of the face. These canvases were on their way to the photographer's artists, who converted the rough shots into spectacular works of art. When I remarked on this, my guide agreed, "It's the artists who transform the images. They're the ones who should receive the praise!"

Of course, the process this photographer relied on years ago was no different than the one many photographers overuse with Photoshop today. As you shoot, your goal should be to get good images straight out of the camera. Don't use Photoshop as a crutch.

...apher. But how much of your and/or your staff's time are you willing to give up correcting excessive shadowing? Or restoring critical focus to the image?

Harder lighting and insufficient fill can create excessive shadowing.

I want to create images in my camera that are 95 percent as good as the final images that leave my studio. Straight out of the camera, these shots require only simply retouching of the lines, circles, and blemishes on the subjects themselves. We avoid using retouching to correct mistakes in lighting that should have been fixed at the time of capture. Outdoors, we don't have quite as much control as in the studio—but we are still *photographers*, and we should be creating images in our cameras, not on our computers.

Therefore, I look for lighting that provides a nice balance between soft and hard lighting. I want a usable shadow that is heavier than what most portrait photographers use, but not so heavy that I need to use postproduction enhancement to make the portraits salable.

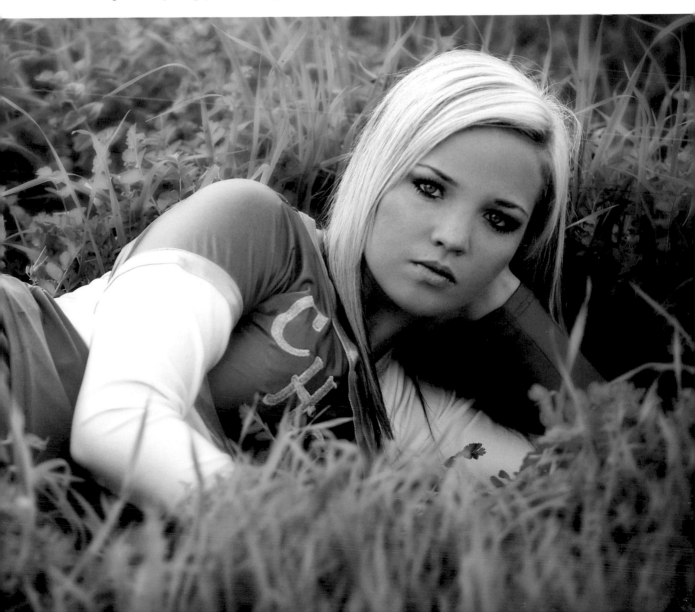

Decision 1:
Find the Background

Many photographers suggest that you first find the light and then determine the background based on that area of ideal lighting. This is the practice employed by photographers who work at those "ideal light" times of day. When I go

I can make the light usable, no matter what it currently looks like.

into an area, however, it is usually in the middle of the day, so my first consideration is to look for usable backgrounds; I know that I can make the light appealing on the subject, no matter what it currently looks like. This is the basic idea of working on location when the lighting isn't perfect—it is much easier to change the light on the subject than the light on the background or the scene around the subject.

Adjusting the light on the subject is easier than controlling the light on an outdoor background.

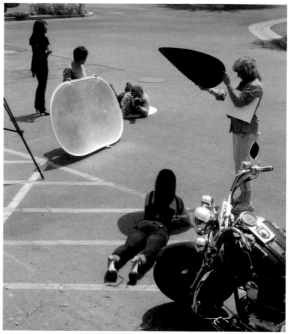

Above and facing page. Once we set up the background, the lighting on the subject was refined using reflected light (see lessons 24–29) and subtractive techniques (see lessons 30–32).

Decision 2:
Light the Subject

Once a background is located, the next decision is whether to use additive light sources, subtractive light sources, or both. This is typically a straightforward decision: if the light on the background is more intense than that on the subject, you must use at least some additive light. However, if the background is lit by the same light as the subject, then subtractive lighting may be enough. There are very few scenes in which the light can't be improved dramatically using additive or subtractive techniques.

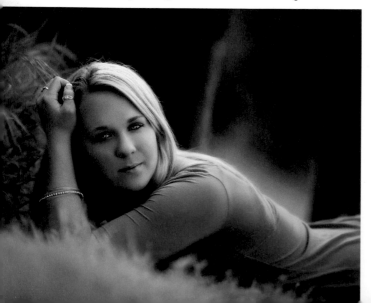

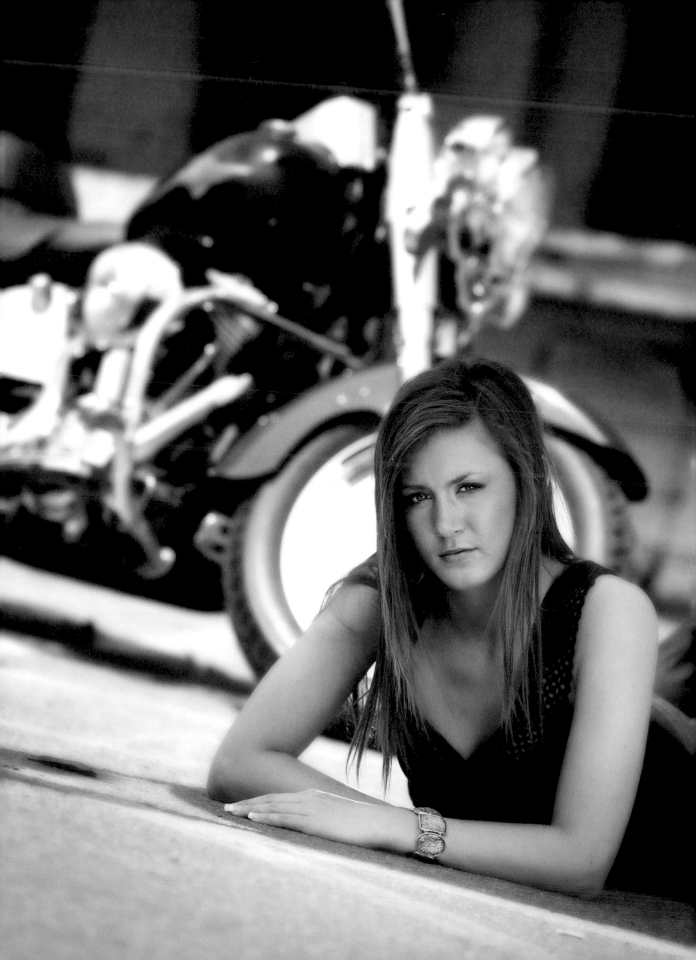

Look for Shade

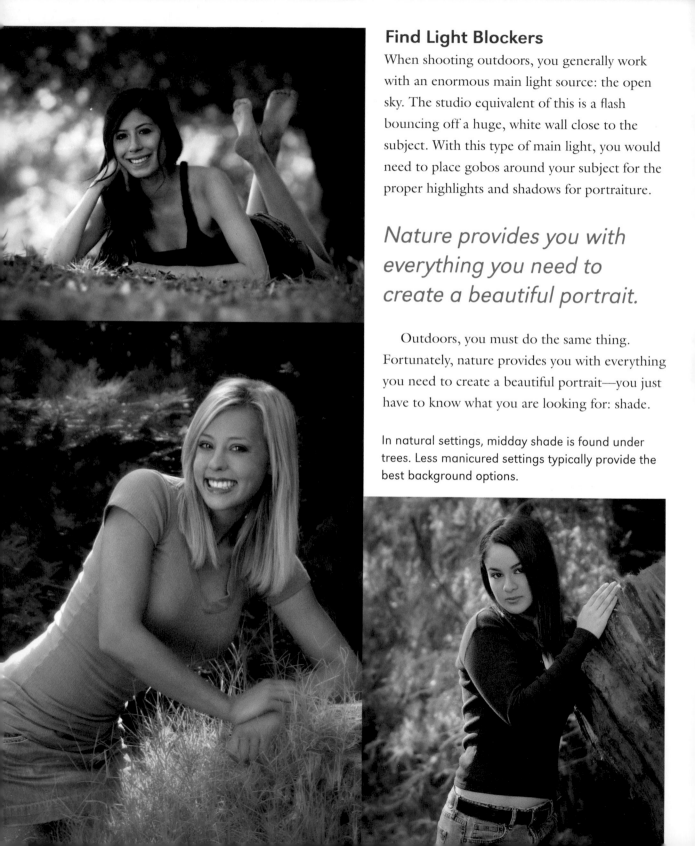

Find Light Blockers

When shooting outdoors, you generally work with an enormous main light source: the open sky. The studio equivalent of this is a flash bouncing off a huge, white wall close to the subject. With this type of main light, you would need to place gobos around your subject for the proper highlights and shadows for portraiture.

Nature provides you with everything you need to create a beautiful portrait.

Outdoors, you must do the same thing. Fortunately, nature provides you with everything you need to create a beautiful portrait—you just have to know what you are looking for: shade.

In natural settings, midday shade is found under trees. Less manicured settings typically provide the best background options.

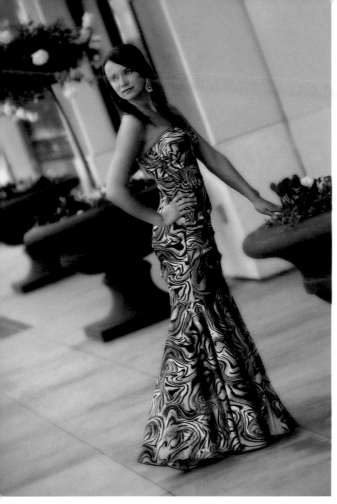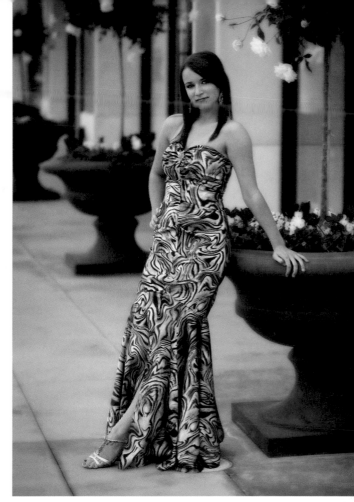

In architectural settings, midday shade is found near tall buildings and below overhangs.

Natural Scenes

The more mature the foliage is in a natural setting, the larger the shaded areas will be. When choosing a setting, look for one that isn't manicured. A natural area has foliage growing at all levels that will block the direct sun throughout the day. Manicured gardens might have tall trees, but the area between the lower branches and the ground tends to be bare. This leaves the bright sky or unwanted objects visible in the background. Rivers often provide good locations for outdoor portraits because of the large trees and dense foliage of varying heights.

What Makes a Location Good?

At midday, the more shaded areas you can find, the more salable images you will be able to create. The location that you select will determine how many usable background areas there will be throughout the day.

Architectural Scenes

Similar rules apply when selecting an architectural setting for urban outdoor portraits: the taller the buildings, the more shaded areas you will have to work with. Covered walkways, patios, or courtyards can also provide usable portrait areas throughout the day.

Welcome Obstructions

As noted, the first thing to look for in a scene is an obstruction to create shade on your subject. If we delve a little deeper into this concept, it becomes clear that what the obstruction is really doing is changing the angle from which the light is allowed to fall on your subject. An overhead obstruction not only blocks the overhead light from the open sky, it *lowers the angle* of the light striking the subject. When the angle is correct,

you'll see beautiful catchlights appear in the subject's eyes (see lesson 23 for more on this).

Too Close to the Edge

Most photographers place the subject too close to the edge of this obstruction. When you do this, you still block the overhead light, but you don't lower the angle of the light from the open

> *Have the subject back up and go farther underneath the overhang.*

sky enough to create beautiful lighting. If you're not seeing great light (and a nice catchlight in the right position), have the subject back up and go farther underneath the overhang. This will lower the angle of light and create the lighting effect you are looking for.

The subject's distance from the edge of the overhang determines the angle of the light.

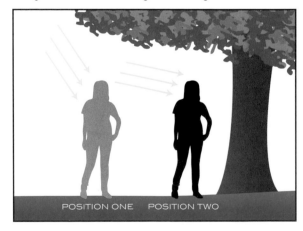

POSITION ONE POSITION TWO

For nice lighting under an overhang, turn the body away from the light, then turn the face back toward it.

My Rule of Thumb

Here's my rule of thumb. First, find the edge of the shadow. In many cases, that will be at the edge of the large grove of trees where the blue sky begins. Then, turn the subject's body toward the shadow (the grove of trees) and turn their face back toward the light (the blue sky). If you follow this rule, your light will always have a nice directional quality. While this is a simple approach that can definitely be improved upon, it is a good starting point.

Watch the Catchlights

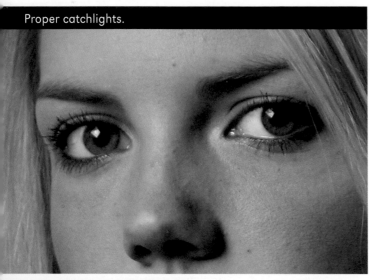

Proper catchlights.

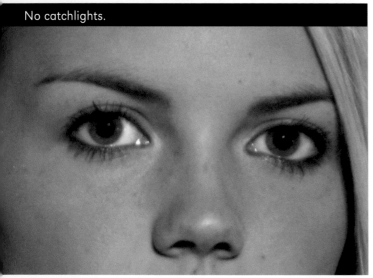

No catchlights.

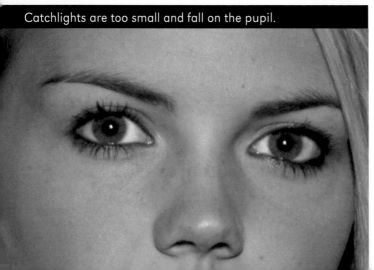

Catchlights are too small and fall on the pupil.

To determine whether or not you've found the right main light source and have the subject positioned properly in relation to it, look at the eyes. Whether I am working in the studio or outdoors, I study my client's eyes every time I change a pose. If the eyes aren't properly lit, you will not have a salable portrait, no matter how perfect the rest of the portrait seems to be.

The Right Size and Position

Mentally divide the pupil and iris into quarters. The catchlights should appear in the upper quarter of each iris. They should be of a medium size, not pinpoints of light, but also not so large that they overwhelm the eye or obscure its color.

Common Problems

Many outdoor photographers make the same lighting mistakes over and over—all because they never take the time to look into their subjects' eyes. Looking at the catchlights can reveal lighting problems. As you look at the photos to

Are the Rules Set in Stone?

Like all things in photography, rules were made to be broken. These guidelines can point you in the right direction, but the final decisions are up to you as the artist. If you have a subject without an apparent shadow area, with broad catchlights going from one side of her eye to the other, but her face looks great in that light, you would be a fool to make any changes.

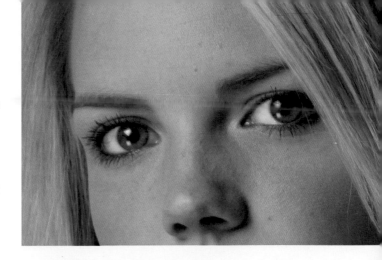

the left, observe the catchlights but also look at the overall lighting on the face. When the catchlights are proper, the lighting on the face is more flattering.

No Distinct Catchlights. Without a distinct catchlight in each eye, the eyes are lifeless. This problem is caused by the absence of a main light source, or the use of one that is so large that it produces an even illumination across the entire eye. In either case, look for more direction in your light source. If the subject is facing into a huge expanse of open sky, look for some ob-

> *When the catchlights are proper, the lighting on the face is more flattering.*

struction to block part of the open sky and give the light a clear direction.

Excessive Catchlights. When you are working at midday, intense light reflects off of everything and can create too many little catchlights. Usually, one of the catchlights is more intense than the rest. You can eliminate the excessive catchlights by turning the subject or placing a gobo to block the light from those sources.

Too Low or Too High. If the catchlight is too low, you usually have a sunlit object or grassy area in front of the subject that is overpowering the light from the sky.

Sometimes you can see a catchlight directly under the eyelid and lacking intensity. This is usually accompanied by "raccoon eyes," or slight circular shadows under the eyes. This usually happens when there is little or nothing over the subject to block the overhead light.

Multiple Catchlights

Many traditional photographers think it is taboo to see a second catchlight in the eye coming from a lower angle. Pick up any fashion/glamour magazine today, however, and you'll see that the majority of the photographs have a second or even third catchlight in each eye. I like this more glamorous look—and my clients do, too—so I often place a reflector below the subject's face to produce a secondary (more subdued) catchlight in the lower part of the iris on the same side of the subject as the main light. If you compare this image with the "proper catchlights" shot on the previous page, you'll see that the added reflector doesn't alter the overall lighting pattern, it just adds a little fill and some extra sparkle.

Too Small. Using on-camera flash outdoors produces a tiny catchlight, as does using a naturally occurring, very small, intense main light source. The result is a very harsh, unappealing look on the face. It's simply not a professional approach.

Watch the Eyes

Look through these images and see what you can learn about the main light from the catchlights. Can you identify the direction of the light? Its height? Its shape? In the insets, the eyes are enlarged to make your study easier.

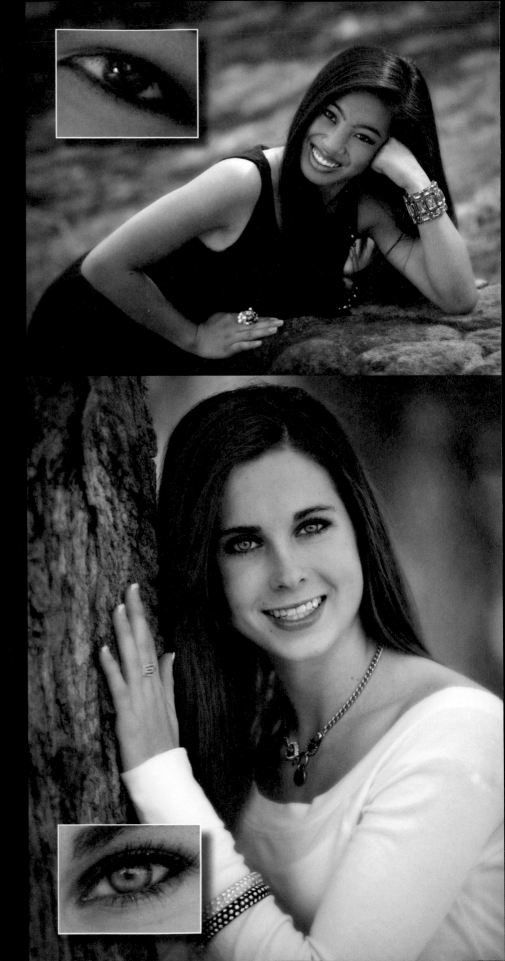

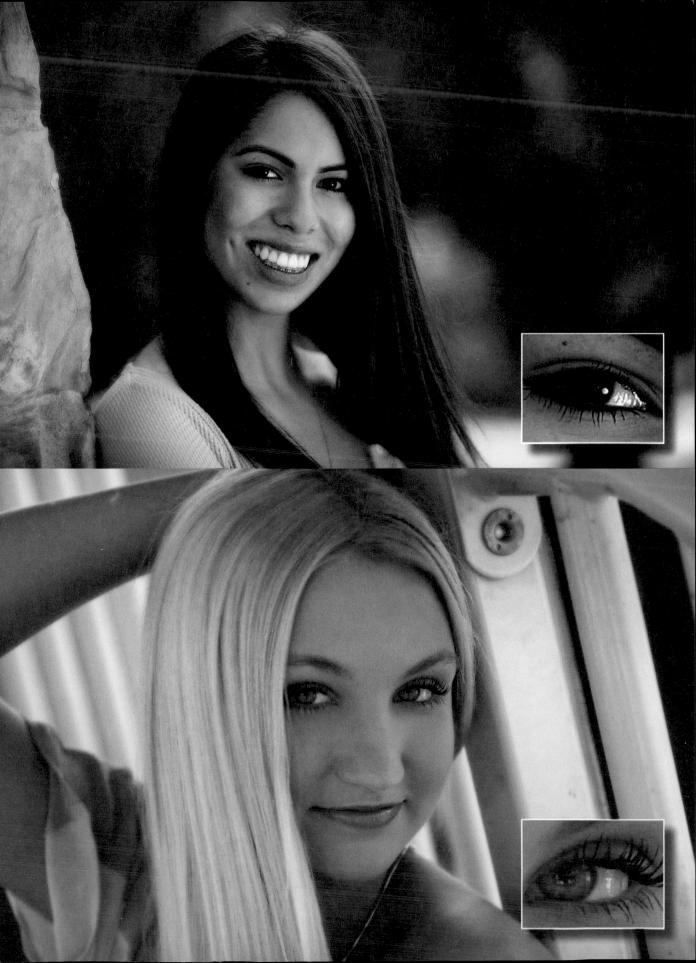

In most portrait lighting setups, when we position the main light and pose the subject, one side of the face is lit (this is called the highlight side) and the other side of the face is unlit (this is the shadow side). Even if the light you are using is very soft, if it comes from one side of the subject, it has direction and creates shadow.

For some portraits, a high-contrast look is integral to the dramatic feeling desired in the image. It suits the subject, clothing, and location.

How Much Shadowing?

You must determine how much shadowing you want. Do you want to see detail in the darkest shadow areas? Or do you/your clients like a deep shadow without detail for a more dramatic look? It is your style, but it's your client's photograph—something they must live with for the rest of their lives—so choose wisely.

Potential Problems

1. **Loss of Detail.** Your eyes can see shadow detail that image sensors are not capable of recording. They simply can't record the full range of tones, from the brightest highlight to the darkest shadow, our vision can perceive. This can result in a loss of detail in areas that exceed the sensor's range.

Digital capture doesn't always do a great job of recording this area.

2. **Poor Transition Areas.** The transition area (described in lesson 18) is what creates the feeling of depth in an image. Unfortunately, digital capture doesn't always do a great job of recording this area, often lacking the smoothness that we saw with film. The digital image sensor's compressed tonal range often results in a transition area that seems to leap abruptly from highlight to shadow.

For outdoor portraits, the easiest way to address the issue of too-dark shadows is through the addition of reflected fill light.

3. **Color Imbalances.** As the skin darkens from highlight to shadow, the skin tones also tend to pick up other subtle tones; often, these areas end up looking greenish (especially with outdoor portraits shot in grassy or leafy areas). This is just one of the many little quirks of working with digital files—and, when it appears, it's an issue we typically need to correct during postproduction.

Controlling the Shadow

The size and darkness of the shadow depends on the softness of the light, which in turn depends on the size of the light source relative to the subject. In outdoor photography (unless we're adding flash; see lessons 33–43), the main light is hard to control. There are three options:

1. **Adjust the Subject's Position.** Adjust the subject's position relative to natural or man-made obstructions (see lesson 22) to make the light smaller and more directional.
2. **Diffuse the Light.** Add a scrim to diffuse the light and make it softer (see lesson 29).
3. **Add Fill.** Add an additional source of light for fill. For outdoor portraits, the best way to do this is with a reflector. (See lesson 37 for why I avoid using flash fill.) Adding reflected fill helps the camera capture the more subtle tonal variations you want to see in a professional image. Continue on to lessons 25–28 for more information on fill lighting, the most common way to control shadows.

How Much Fill?

There's no magic solution to how much or how little fill you should use. Sometimes, a bright, open look is perfect for your client and the end use of the portrait. Other times, shadows are needed to enhance the mood and drama of the image.

The directional light we've been using so far, sunlight with some overhead obstruction, is as close as it gets to being ideal on midday shoots. Most of the time, however, I find that the light nature has given me, even in an almost perfect setting, can still be improved.

As I look into the eyes of a subject in this lighting situation, I usually feel that the catch-lights are not quite intense enough or that the eye color isn't sufficiently visible. Adding a reflector for a touch of fill from below the sub-ject smooths the complexion and brings more emphasis to the eyes.

How Reflectors Work

Reflectors come in all shapes, sizes, and surfaces, but the operating principle is the same: they redirect light from its source (in our case, the sky) to wherever you need it in a scene. About half of the images in this book were taken using reflectors exclusively.

Types of Reflectors

A reflector can be anything from a piece of foam-core board with duct-taped edges, to a PVC-pipe frame with fabric stretched over it, to any of the commercially manufactured reflec-tors—and everyone has their own opinion as to which is best. Photographers who like the rigid frames say that, with a few stakes, they can

An assistant positioned the reflector for a nice level of fill light and extra sparkle in the eyes.

An assistant positioned the reflector below my subject's face.

work in the wind; photographers who like the soft reflectors argue that when their reflector blows away, they aren't going to harpoon the girl down the beach. The choice and the risk are yours! Again, the most important thing is learning to use what you already own, not buying a whole bunch of new equipment.

Even in an almost perfect setting, I find that the light can usually still be improved.

My most-used reflector is a 42-inch white/silver collapsible disk. It is lightweight, easy to use with one hand (often, while I am photographing with the other!), and a great size for when you are working closer to the subject. I have a variety of reflectors, both rigid and collapsible, ranging in size from 16 inches to over 6 feet. The finishes range from white, to silver, to highly reflective silver—almost a mirrored finish.

While reflectors work well for me, they may not be ideal for everyone. I work with assistants who can hang on to the reflector when a breeze comes up; without their help, many of my reflectors would have been washed out to sea.

Keep It Simple

Although we photographers tend to love fancy equipment and the idea of pulling out "the big guns," don't forget these old words of wisdom: "Keep it simple, stupid!" (also called the KISS principle). When one reflector will give you a salable portrait, don't use anything more.

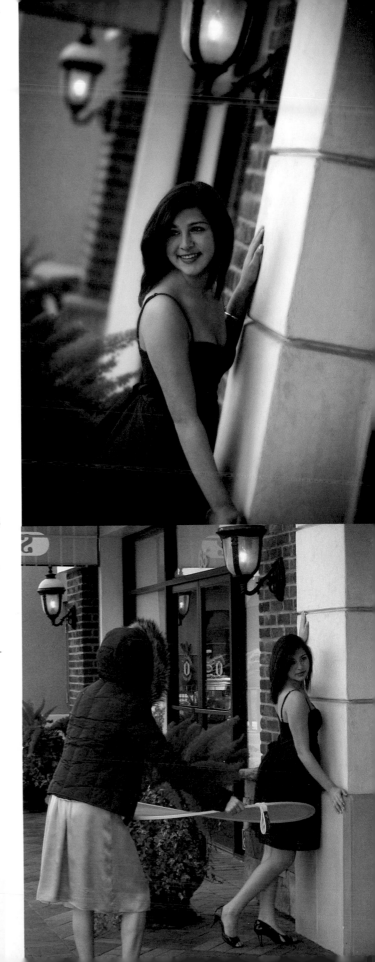

Size

The size of the reflector controls the amount of light it produces and the breadth of the area it covers. A larger reflector, just like a larger soft-box, will produce softer light and larger catch-lights in the eyes; a smaller reflector will produce more contrasty light and smaller catchlights.

Surface Material

The surface material is selected more by the volume of light needed than its characteristics. While light reflected from a silver reflector will have more contrast than light from a white re-flector, it is usually the amount of light you need that makes you choose one over the other.

How to Choose

The type of reflector I use varies depending on the ambient light situation. It's important to consider the following three factors:

1. The amount of light available to reflect.
2. How much light you need reflected in order to balance the scene.
3. The desired characteristic of the light.

What Effect Do You Want?

In the studio, we select a main-light modifier based on the characteristic of the light it will produce. Outdoors, we do the same thing: we select the size and surface material of a reflector based on the results we desire.

The white side of the reflector provides the softest light. I always start off with white and, if it is bright enough, I use it. I use the white side most often when I am positioned in direct sunlight and the subject is in shade.

Unfortunately, white sometimes doesn't reflect enough light. In these cases, switching to a reflector with a metallic finish will bounce in a greater volume of light. Silver reflects the same color of light as the source. The gold material

Below and facing page. The side of the hill was backlit with direct sunlight on the grass and the sub-ject. (Foliage looks best when backlit; it brings out the most vivid colors.) I didn't want to completely overpower all this beautiful light, so a simple white reflector, placed close to the subject and bouncing back the sunlight, was just enough to beautifully light her face without overpowering the backlight.

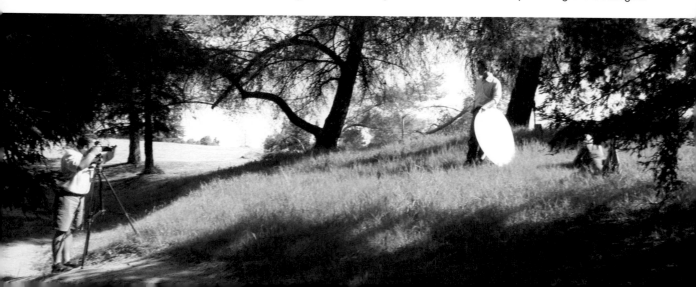

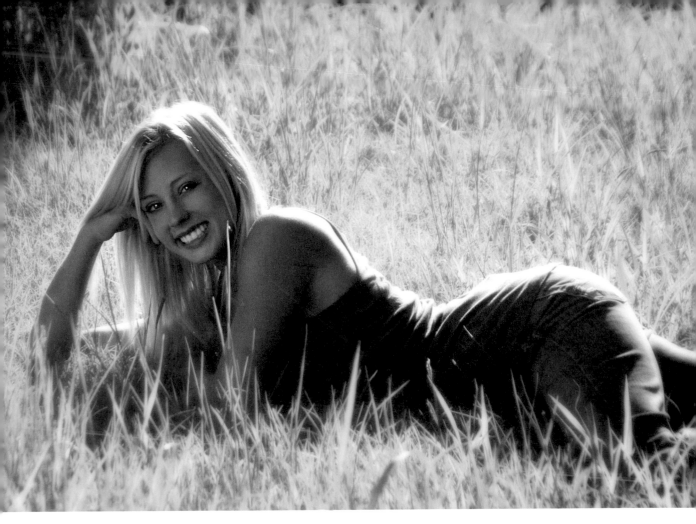

warms the light color, which can be nice for outdoor portraiture.

I also use these metallic surfaces when I'm positioned in shade and when I'm working at a distance from the subject. The greater the distance there is between the reflector and the

The size of the reflector controls the amount of light that it can produce.

subject, the greater the distance the light must travel, and the less intensity it will have. With full-length poses or when shooting with longer lenses, the reflector is usually at or near the camera position. That's a long way for reflected light to travel, so the metallic finishes help boost the intensity to the needed level.

Distance Changes Quality

Keep in mind that as the distance to the subject increases, the light source also becomes smaller in relationship to the subject. As a result, its effect becomes harder. For that reason, you may want to opt for a large 6-foot reflector rather than the more common 4-foot models. To position it, you can hook the loop of the reflector over one of the knobs on your tripod and rest the bottom edge on the ground. Alternately, an assistant can be assigned to position the reflector as needed.

Pros and Cons

Reflectors offer many advantages over using flash outdoors. Most reflectors are lightweight, easy to transport, and they don't require electricity. Best of all, the lighting effect you see is the lighting effect you get.

The only downside to reflectors is that the light bounced from them can be brutal—especially to someone who has light-sensitive eyes. It can create a variety of subject reactions, from squinting to the entire face wrinkling up. (See "Reduce Squinting" sidebar on the facing page.)

Reflected Main Light

The reflected light is especially intense when you use it as the main light. This can be a useful approach when your existing main light source is too large. Positioning a reflector to bounce a beam of light onto the subject creates the more directional light quality we're looking for.

Best of all, the lighting effect you see is the lighting effect you get.

Reflected light can be an effective main light source when your subject is backlit. As shown in the images here, the overhead light was blocked by a tree—but the most intense light came in from behind, creating highlights that separate the dark hair from the dark background. (This is the same effect we'd create with a hair light in the studio.) To light the face, I positioned a reflector to camera left to catch some of that intense backlighting and redirect it onto the front of the subject. A second reflector was added below the subject, slightly to camera left, for fill and subdued secondary catchlights in the eyes.

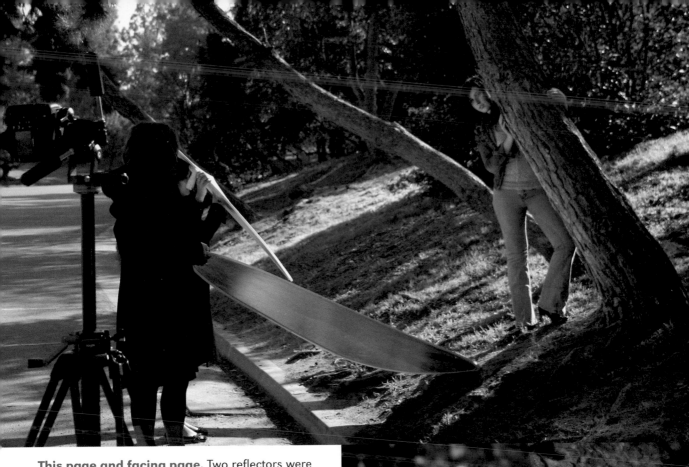

This page and facing page. Two reflectors were used to illuminate my backlit subjects.

Reduce Squinting

Some subjects can handle direct sunlight reflected into their eyes—at least for the brief time it takes to do the portrait. If your subject is particularly light sensitive, ask them to close their eyes and tell them what expression you want them to have when their eyes are opened. Keeping their eyes closed, count to three, guiding them as you say each number. "One. Okay, start smiling. Two. And three—open your eyes." It may take a few shots to get the pattern down, but for the instant it takes to snap the portrait, your client's expression will be comfortable.

Reflector for Fill

When it comes to adding fill light (and a bit of extra sparkle in the eyes), it doesn't get much more straightforward than adding a reflector. What you see is what you get and the effect can be endlessly finessed by having an assistant adjust the position of the reflector.

Why to Do It

Unless you are using the reflector at quite a distance, raw sunlight bounced directly onto the subject's face will be quite harsh. To get softer lighting, you need to use just the light rays from the edge of the light source (this is true whether that light source is a softbox, an umbrella, or a reflector). Some photographers call this "feathering the light." This will reduce the intensity of the lighting and soften its effect.

With Reflectors

In the studio, it is easy to see the effect of feathering, because you have subdued lighting in the shooting area and a strong modeling light. When using reflectors outdoors, the differences are more subtle. Here's how to do it:

1. **Find the Light.** Often, you will have to keep moving and changing the angle of the reflector to see where the beam of reflected light is striking.

With the subject in the shade, a reflector was positioned to bounce light from the open sky. The beam of reflected light is visible above her head.

2. **Place the Beam Above the Subject.** Once you have control of the beam, angle it well above the head of the subject, then slowly lower it. (Don't start from a low position and raise it; see "A Common Mistake" [below] to learn why.)

3. **Gradually Lower the Beam.** When the direct beam of reflected light is five or six feet above the head of the subject, you will notice the face starting to brighten up, and you'll see more distinct catchlights appearing in the eyes. As you lower the beam, you will notice more and more light illuminating the face.

4. **Hold That Position.** Stop when you have the intensity and quality of light you want. Be sure to use just the edge of the light rays; keep the harsher central area of the reflected beam above the subject.

A Common Mistake

Don't use the reverse of the feathering procedure described above. If you angle the light beam down to the ground level and work up, you will stop when the light effect on the face is what you want. Unfortunately, the waist area (if the subject is standing) or foreground area (for a subject seated on the ground) will still have the direct beam of light hitting it. That will make it much lighter than the face. You will be drawing the eye of the viewer away from the face and straight to the subject's stomach or the ground.

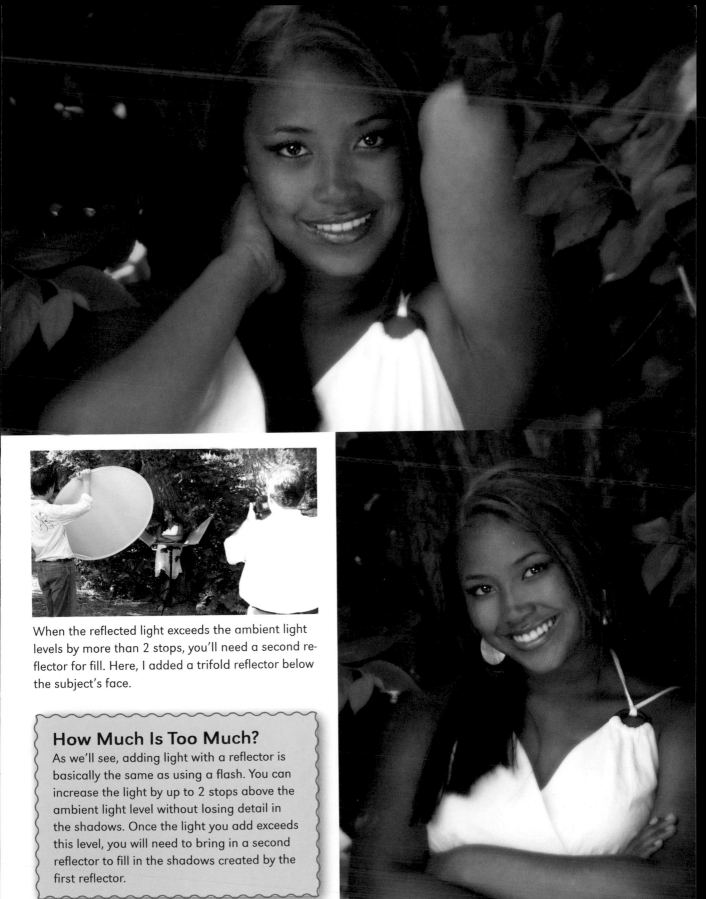

When the reflected light exceeds the ambient light levels by more than 2 stops, you'll need a second reflector for fill. Here, I added a trifold reflector below the subject's face.

How Much Is Too Much?

As we'll see, adding light with a reflector is basically the same as using a flash. You can increase the light by up to 2 stops above the ambient light level without losing detail in the shadows. Once the light you add exceeds this level, you will need to bring in a second reflector to fill in the shadows created by the first reflector.

Mirrors and Scrims

Mirrors

Mirrors can be used alone as accents, for separation lighting, or to raise the overall illumination of a shaded space. Many times, small hand mirrors can add just the right amount of light for an accent on the hair or another part of the subject. As with any other light source, the size of the mirror will change the look of the light. We use

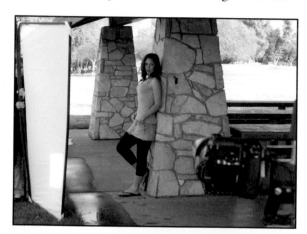

old glass mirrors left over from when we remodeled, but if I were to buy them today, I would use Plexiglas mirrors to save on weight.

Scrims

A scrim is a piece of translucent fabric that softens the light passing through it. I typically use a rigid-frame fabric panel. With two panels clipped together to form an A-frame, the scrim is freestanding. It also gives me more control over the natural light, since the second panel is available to add black fabric or another scrim.

Mirrors with Scrims

I've grouped these two modifiers because they work well together. The mirror is used to redi-

Two mirrors were used to bounce intense daylight through a scrim.

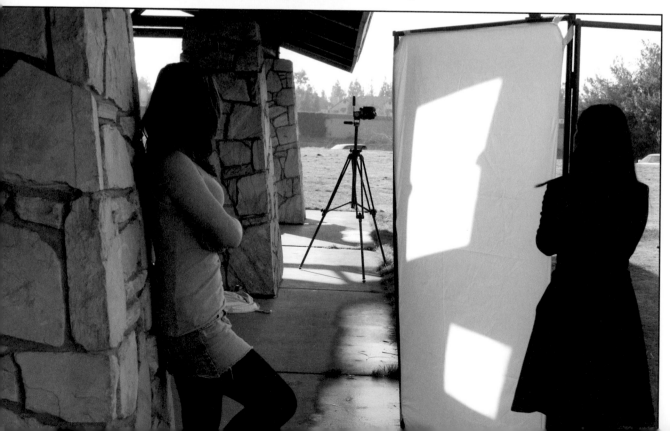

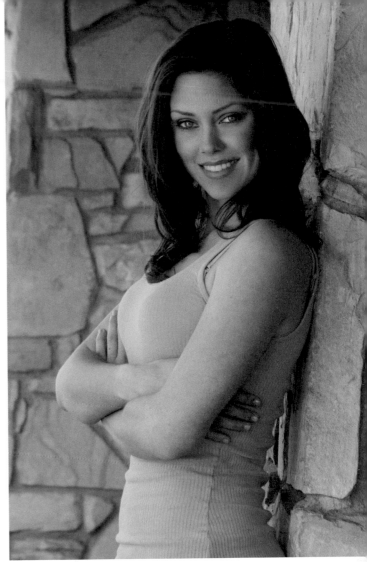

Above. With the available light only, the effect was unflattering (no wonder she's not smiling!). **Right.** Bouncing in main and fill light sources through a scrim produced a professional look.

rect the sunlight to an appropriate position for the main- and fill-light sources, then the scrim is used to soften the light. I typically use a larger mirror (around 24x30 inches) for the main-light source and a smaller mirror (around 11x14 inches) for fill from below the face.

While using mirrored light and a scrim is more cumbersome than using a reflector, the light that it produces is much more controllable. Reflectors must be twisted and angled to get the needed light into the correct area—and many times the position you need to place the reflector in to get the light just right is less than ideal.

This technique also gives you more control over the characteristics of the light. While the size of the reflector does affect the size of the beam of light it provides, it isn't all that controllable. With a variety of mirror sizes and the ability to put multiple diffusion panels on the same frame, much more control of the light is possible, while still providing a natural-looking light source.

What's the Advantage?

Just as with reflectors, what you see is what you get. Unlike reflectors, however, this technique allows you to bring a very bright daylight source down to a usable level—without burning the subject's eyes or getting shiny skin.

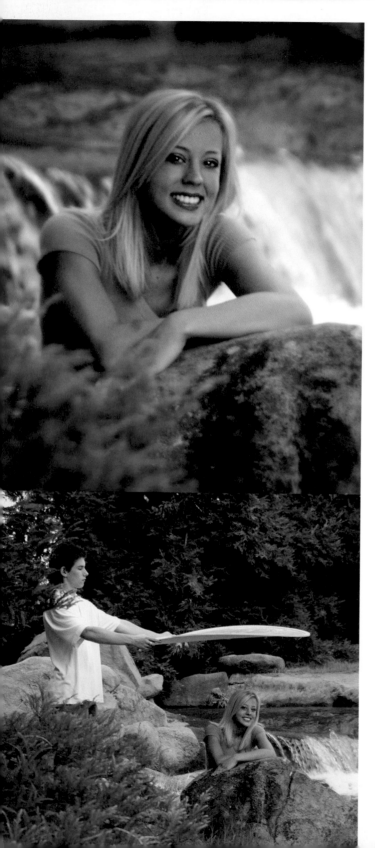

We've already looked at how natural obstructions can improve the quality of your midday portrait lighting. But what if there are no natural obstructions in the area where you want to shoot? No problem—just add them.

Subtractive Lighting

The process of adding shadows is sometimes referred to as subtractive lighting (because we create shadows by removing light). For example, if you see flat lighting on the subject's face, you know that your main-light source lacks direction and is too large. To correct the problem, you need to remove some of that light by putting a black panel, gobo, flag, or other light-blocking device on the side of the subject where the shadow should be.

What Device to Choose

Which type of light blocker to use will depend on the circumstances. Black devices block light from the desired area, but they also tend to suck the light out of neighboring areas. Depending on the light levels and scene, white blockers can actually bounce some light back onto your subject, adding a color cast or changing the desired appearance of the lighting.

Let's imagine you are placing a gobo above a subject to block the overhead light. If the

Man-made obstructions are just as useful as existing blockers of overhead lighting—and much easier to position.

Adding a light blocker created a nice spot of shade on the bridge.

subject was standing in a grassy area, I would typically use a white gobo (a typical pop-out reflector will work). The ground won't cast enough light up into this white gobo to make it act as a secondary light source, so it won't affect the lighting on the face.

If, on the other hand, the subject was standing on light-colored concrete in direct sunlight, the concrete would kick up plenty of light. A white gobo overhead would bounce that light back down onto the subject's face, changing the look of the lighting. In this case, switching to a black device might be necessary—even though it can excessively darken the hair on the top of the head.

An assistant can hold the gobo in place.

Train Your Eyes

You can train your eyes to take notice of slight variations in the light. When you first started creating images, you probably shot a portrait that your eyes told you looked great, but when you got back to your computer you noticed an awkward hand pose or white socks beaming out of a dark pant leg. With experience, you learn how to scan a subject from head to toe and fix these little problems before shooting. Likewise, you can learn to see the way subtle changes in light and shadow will be recorded in your images.

The easiest way to learn subtractive lighting is to start with a subject and available light only. Then, one by one, you can add the lighting controls you need and observe their effects as you transform the simple portrait into a more salable, professional image.

Step 1: The Problem

In the first image (left), you see this beautiful young lady posed in a typical outdoor location. The amount of light in the subject's area is relatively close to the amount of light on the background area. This means that we will not have to add light to balance the scene (*i.e.*, darken the background). However, because the light is coming down from directly overhead,

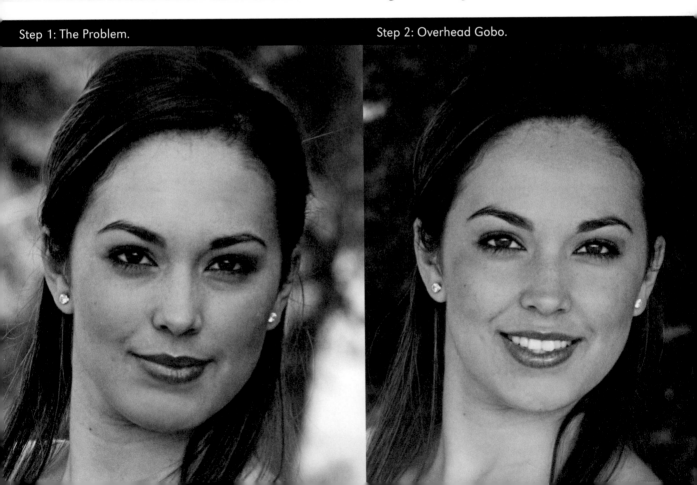

Step 1: The Problem.

Step 2: Overhead Gobo.

the subject has raccoon eyes as well as some very unattractive highlights on both her forehead and nose.

Step 2: Overhead Gobo

The first correction I would make is to place a white reflector above the subject's head to block this unattractive light. I would use white here because the shaded grass will not reflect enough light up to the white reflector to affect the final image. In the second photo (center), you can see the improvement in the lighting with just that one correction.

Yet, while the image is improved, there are still some problems that need to be corrected. The eyes have nice catchlights in them, but the face has no shadowing or transition zone to draw the viewer's eyes to the most important areas of the face and hide those that shouldn't be seen.

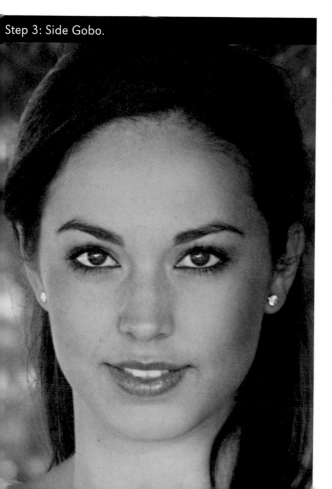

Step 3: Side Gobo.

Could It Be Even Better?

As you look at the third image, you see a little highlight toward the end of the nose. This means that the main light is wrapping too far around the subject. To compensate, you could put another black panel on the opposite side of the subject to reduce this side light—but that would create a second shadow on the highlight side of the face. A better solution would be to use a piece of translucent fabric. Placed to camera left, this will reduce the light coming from the side without creating a second noticeable shadow area.

At this point, this image is already better than the outdoor portraits you'll see displayed by some studios. Still, let's take it one step further. Since most of the lighting in this scene comes from above the subject, I would suggest adding a white or silver reflector below the subject's face to give the portrait a more glamorous look. The light from this reflector will bring out more of the eye color, soften any darkness under the eyes (something just about all of us have), and help to smooth the complexion. For a reflector in this position, I generally use white when reflecting sunlight and silver when reflecting light from a shaded area.

Step 3: Side Gobo

The next step would be to place a black panel on the right side of the frame to establish a shadow zone and create a transition from highlight to shadow. In the third image (right) you see the effects of this change. The face appears thinner and the structure of the face is more noticeable.

Is there more we could do to improve the look of this image? Definitely. Check out the sidebar above ("Could It Be Even Better?") for some ideas.

Subtractive lighting is one of the simplest ways to control the lighting in an average scene. Therefore, I have used these principles to assemble a photo booth that provides perfect outdoor lighting with any outdoor background.

Construction

This booth consists of a 4x8-foot black panel on a rigid frame, a translucent panel on a rigid frame, a white reflector attached to the two pan-

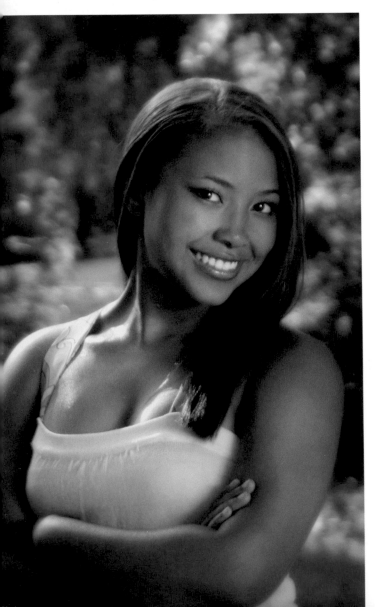

els with clamps, and a white or silver reflector clamped at the level needed to provide light in the appropriate place for a head-and-shoulders pose.

Positioning

This photo booth makes outdoor lighting very easy. To use it, I look for an area that has strong backlighting, usually provided by the sun. I want to have the subject separated from the background by a backlight because the majority of my clients have darker hair (plus, I advise them to choose darker shades of clothing). When I can find this backlight, I use the white reflector; when working in a shaded area with little or no backlight, I use the silver reflector.

I want to have the subject separated from the background by a backlight.

The only variable in this setup is the main light. In most scenes, the area in front of the subject will be open sky, providing a fairly good main-light source—at least with all the photo-booth's modifiers in place. Should the area have obstructions that don't provide a usable main-light source, you can simply add a reflector or scrim with mirrored light to produce one (more on that technique in lesson 29).

Beautiful lighting with the subtractive light booth.

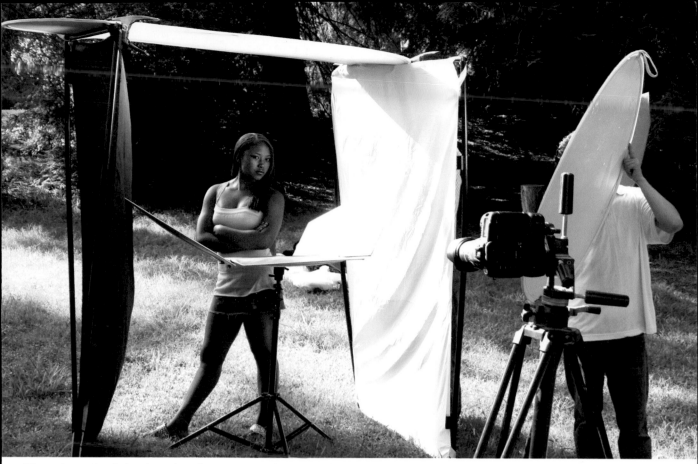

The subtractive light photo booth setup provides nice lighting for head-and-shoulders portraits.

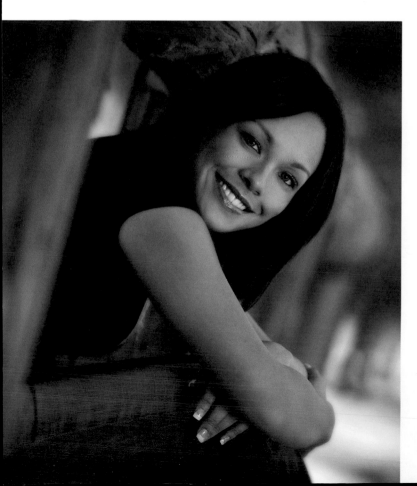

File Management

I use a separate flash card for each session I photograph during the day. When I finish a session, my assistant takes the card to my truck and downloads the images onto a laptop, placing them in the client's folder. He then puts the card into the client envelope so the images are saved in two places for safe keeping. At the end of the day, the images from the laptop are downloaded to the studio's server and two DVDs are burned— one for the client file, and one as the daily backup file.

We have come just about as far as we can using the available light only. When you need to overwhelm the natural light to make a scene usable, flash is your best bet. Flash is part of the recipe that allows me to shoot outdoor portraits all day long.

Advantages of Flash

Adding flash outdoors allows you to work with more backgrounds and create more looks for your clients. Instead of being forced to place yet another client under your favorite tree—the same one that probably appears in hundreds of your images—you'll have the ability to explore other locations and still produce professional-quality lighting.

Opt for Studio Flash

When I use flash on location, I use Alien Bees studio lights (with a variety of light modifiers) powered by the Alien Bees battery. This is the first reference I have made to a specific brand of equipment, but I am so impressed with these lights that I wanted to share it with you (and, no, I don't get any free lights or financial compensation from Alien Bees!). Alien Bees lights are lightweight, durable flash units that cost between $200 and $300 depending on the light output. They have a line of accessories

Below and facing page. Adding flash lets you take advantage of locations that would be hard to use with natural light only.

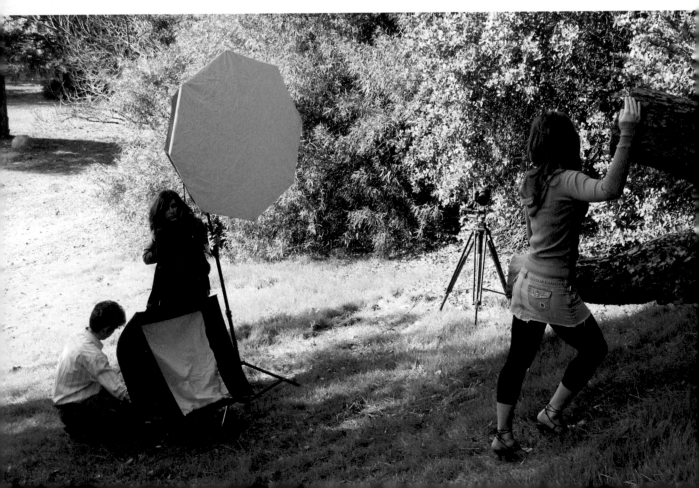

that are very modestly priced and all light box manufacturers (at least all that I have found) offer backplates to fit them. A flash tube for my Alien Bees costs about $30, as opposed to the $150 to $200 for the other brands of lights I use. Don't sell your current lighting equipment to buy Alien Bees, but when you are in the market for new lights, check them out.

When you need to overwhelm the natural light, flash is your best bet.

Outdoors, I take the most powerful Alien Bees, which are approximately 600 watt-seconds. I also use heavy-duty light stands secured with sand bags or weights to keep the light from falling when the wind kicks up.

For most of my flash work outdoors, I use a large octobox from Alien Bees, although I do have some smaller light boxes, as well as umbrellas for when they are needed.

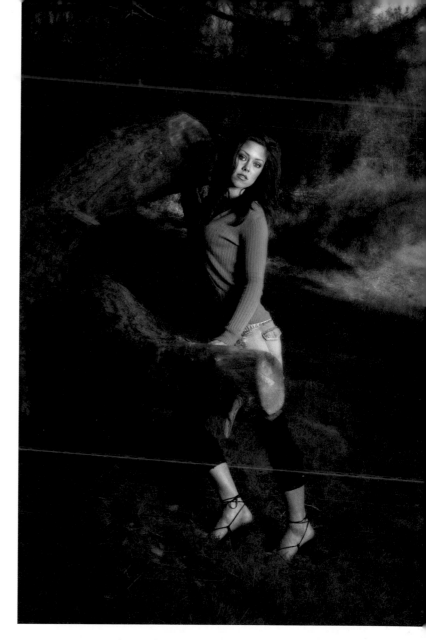

What About On-Camera Flash?

When I go to parks for outdoor sessions, I see photographers using their on-camera flashes and popping off shots with no consideration as to the direction or quality of the natural light. The camera is set on TTL and away they go!

If you think this is a viable option for creating professional-quality outdoor portraiture, I have a question. If I gave you an on-camera flash and asked you to create a professional-quality portrait in the studio, what would you tell me? Most of you would explain that this is not a viable light source for professional studio portraits—or that this light source is extremely limited when you compare it to all the options possible with professional studio flash units.

If on-camera flash wouldn't be your first choice in the studio, why should it be acceptable outdoors? In their defense, many photographers would say, "Because it's easy." That may be, but portrait clients will not consistently buy this type of image from an outdoor session. Success rarely comes from what is easy.

Since I wouldn't use on-camera flash as the main-light source in the studio, outdoors I use it only for an accent light if one is needed.

Know What You *Need*

When I conduct workshops, young photographers always want to look at the equipment I use. They are often disappointed, however, to see that they already have nicer and newer equipment than I do. They sometimes ask why I use outdated equipment when I could buy any type of equipment I want. Here's what I tell them: What I have does the job.

The time to get new gear is when your old gear no longer meets your needs.

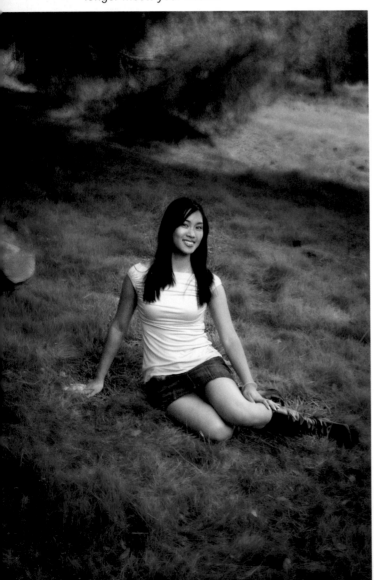

If you buy a camera today and it produces the necessary quality for the images you sell to your clients, who says you need to buy a new camera in 2 years, 5 years, or even 10 years? Likewise, if your lights work for what you do, why would you replace them until they break?

Invest Wisely

Photographers waste *huge* amounts of money buying and trading equipment in the hopes that the gear will somehow make them better. I see too many photographers who literally don't have a spare dime but are carrying around all the latest cameras, lenses, and lights—and, no doubt, the credit card payments to match!

Each piece of equipment I spend my hard-earned money on is an investment.

Don't be led astray when you see workshop instructors demonstrating all the latest products at their seminars. These photographers are given

It's Not About the Camera

At a workshop I recently led, a wedding photographer commented that you wouldn't want guests showing up at a wedding with better cameras than yours. I laughed and explained that I bet there were high school seniors (my clients) with better cameras than mine—but the camera is not important, it's what you do with the camera that matters.

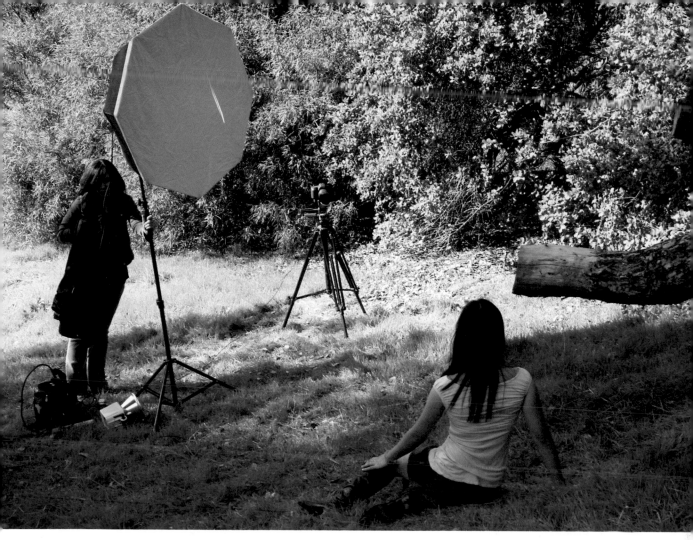

Below and facing page. An octobox produced enough soft light to balance the subject with the background. Does it matter what brand the box is? Or how old? Not really.

the equipment in exchange for selling you on the idea that *you too* need the latest version of everything to be a good photographer.

I run a business (and probably you do, too—or at least you want to), so each piece of equipment I spend my hard-earned money on is an investment. Therefore, I use it until it either wears out or prevents me from offering a product/service that will generate additional income.

If you look at the busiest studios and photography companies, the ones "making bank" in this competitive industry, you will find the most

worn-looking equipment you have ever seen. We use it until it is *done*.

What's the Best Investment?

Photographers who lack confidence often try to overcompensate through new equipment and big lenses. Don't! Focus that attention and money on your education. What you learn will take you much farther than any equipment you could buy. And once you get to a point where you can buy any equipment you want, you'll discover you don't need it.

When most people start out, they select their main light modifiers based on what's being used by the instructors and other professional photographers they admire. Typically, they don't question (or really understand) *why* they should use softbox X or octobox Y—they simply assume the pro knows what they're talking about. You should decide for yourself the best-possible tool for the job at hand.

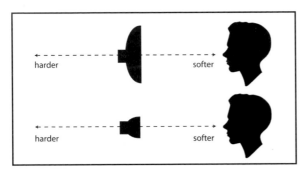

Size

In general, the larger the light modifier, the softer the light will be. But this, of course, is relative to the distance of the light from the subject. If the distance to the subject remains the same, a 2-foot softbox will produce a harder light quality than a 4-foot softbox. However, if you move either softbox closer to the subject, the light will be larger relative to the subject and, therefore, softer. For example, placing a 2-foot softbox 4 feet from the subject will produce softer lighting

Left. Regardless of its size, as the distance between the modifier and the subject grows, the light becomes progressively harder. **Below.** How much does the shape of the main light modifier matter? Not much. These are some of the many light modifiers I use in my day-to-day studio photography.

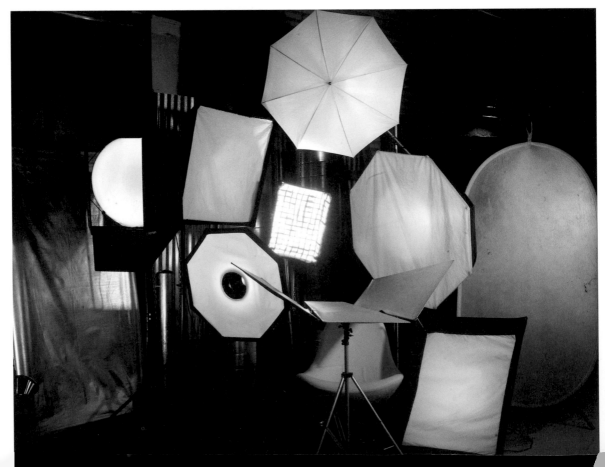

than placing it 8 feet from the subject. This is an important lighting concept to understand.

Shape

Shape is irrelevant. I can do anything with a square light modifier that I can do with a round or octagonal one. The only real difference will be the shape of the catchlights in the eyes—and the concerns about this, in my opinion, are based on the opinions of people with way too much time on their hands.

I can do anything with a square light modifier that I can do with a round one.

Square, rectangular, round, or octagonal—it's really a choice you can make based on what you get used to working with and have on hand. I have them all, and I don't really prefer one over the other.

The Front Panel

More important than the shape of the box is the type of front panel. One isn't better than another; each is suited to a specific purpose.

Most softboxes have a flat front panel. On some units, that panel is recessed, meaning the front panel isn't flush with the very front edges of the light box but inset 2 to 3 inches. The resulting lip around the perimeter directs the light more efficiently, reducing stray light rays from the sides of the main beam of light. The beam of light falls precisely where you place it and falls off (fades in intensity) very quickly so it doesn't spill light anywhere you don't want it.

A convex front panel (top) and a recessed flat front panel (bottom).

The second type of front panel is the convex front panel, which curves out past the side walls of the light modifier. This produces very broad, soft, and beautiful light—especially when it's feathered. If you want lots of gentle light to pour all over your subject, this would be a good type of modifier to choose. Halo and Starfish lights have this type of front panel.

Who's Paying?

Years ago, I heard a speaker at a convention professing that the only film he would ever shoot was Kodak—he declared that he would never think of changing. Exactly ten months later, I went to another one of his seminars, which came to my city, and he was saying that Fuji film was the best! I guess Kodak didn't sponsor that tour.

To use flash outdoors, as in the studio, you must understand the characteristics of different types of light and learn how to control them.

Controls to Consider

There are many factors that can impact the characteristics of the light: the size of the modifier, the interior fabric, the diffuser panels, the position of the light in the modifier, the use of louvers and grids, as well as the angle of main light to the subject. Here are the factors to consider:

1. The larger the light source, the softer the lighting will be.
2. The closer the light source is to the subject, the softer the lighting will be.
3. A silver interior on a light box will provide more contrast than a white interior.
4. The opacity of the front diffusion panels will affect the characteristics of the light.
5. The closer you place the light to a 90 degree angle to the subject, the more contrast the light will have. The closer you bring the light

Use What You Have

I am all about working with what I have to produce the look I want. You don't need every gadget known to man, you need to learn how to control light so well that you can reliably produce exactly the look you want. For example, if you only had a 4x6-foot light box and the effect it produced was too soft, you could:

1. Power up the light and move it further from the subject.
2. Take off the front diffusion panel.
3. Move the light more toward the 90 degree position.

to the 45 degree position in relation to the subject, the softer the light will appear. It will produce less shadowing to contour the subject.

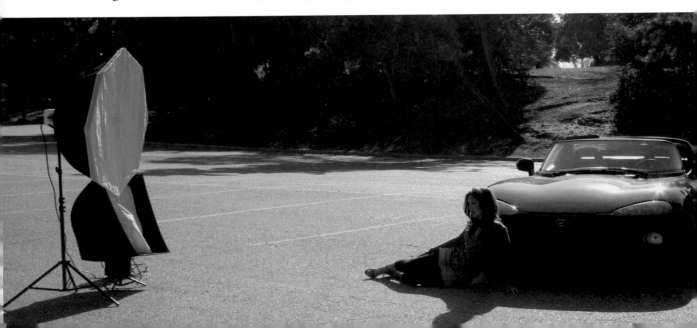

Above and facing page. By adjusting the size, distance, angle, and power of your flash units, you can create lighting that coordinates with the look of the available light in the scene but is more flattering on the subject.

Using these controls, you can freely adjust the look of the lighting and, thus, the outcome of the image. Knowing these controls will also help you make the best use of the lighting gear you own (or have with you at your outdoor shoot).

Knowledge is power—and when working on location you test your knowledge of lighting every day. Each scene, or setting, or side of a building will be different, and it's never controlled like in the studio. The creative process of working with flash outdoors is no different than in the studio. You first decide what you want and what the client intends the end product to be. Then, you make the required decisions to lead you to that result.

Is It Really a Bargain?

With the number of new photographers entering the market, and the availability of cheap products from China, there are many companies putting together complete "studio lighting packages." Containing an array of stands, umbrellas, and lights, these look attractive because of the price—but you will quickly tire of the limited power, the cheap quality, and the inability to purchase standard light modifiers like those discussed in this book.

To Balance the Scene

As you look out from your photographic safe haven, the perfect lighting under your favorite tree, you can see a variety of beautiful scenes in front of you. Unfortunately, the sun is beating down—frying all those beautiful backgrounds to a crisp. Direct sunlight can ravage a background.

Natural light is much too soft and delicate to try to fill the shadows with flash.

You do have some options, of course. You can find a shaded area and set your camera for that lighting, letting the sunlit background step-up to a higher key. This works if the background is dark enough, the shaded area is bright enough, and the light on the background is soft enough.

If the background is a lighter tone, the shaded area is too shaded, or the background is lit by direct sunlight that is not filtered through trees or reduced in intensity in any way, you need to either move or bring up the exposure on your subject to better match the exposure on the background. In short, you need to add light—and if you need to add a lot of light to achieve this balance, studio flash will be your best option.

To Create a Main Light

In outdoor scenes, flash should only be used as the main light, not as fill for the natural light.

Balancing the scene and subject is critical to professional portraiture—and sometimes flash is the best way to achieve that objective.

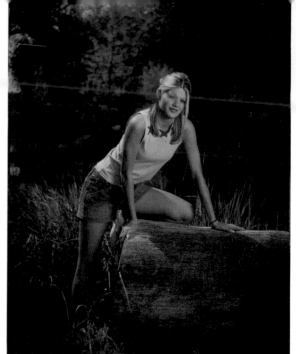

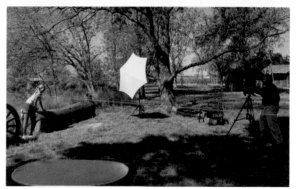

To achieve a professional quality of light outdoors, you must use the same type of lights and modifiers that you use in the studio. In the top left image, you can see how this scene (and the subject) looked with just the ambient light. With correctly balanced flash usage, the results are much more appealing, as seen in the top right photo. The setup I used to create the final portrait is shown to the right.

In my opinion, natural light is much too soft and delicate to try to fill the shadows with flash. Attempting to use flash for fill outdoors causes most of the unnatural lighting you see in outdoor portraits.

When you use your flash as the main light, setting it to meter higher than the ambient light, the natural light (the light that naturally exists) becomes your fill. Or, as you'll see in many of my setup shots using flash, you can add a second flash unit for fill on the subject. Either way, the lighting can be increased to balance a scene and give you control over the ratio between the highlight and shadow areas.

For Full-Length Poses

Flash gives you the greatest ability to balance the lighting on your subject against the lighting in a larger scene, making it ideal for full-length poses. Another reason it works well in these longer poses is because any slight imperfections in your lighting won't be as noticeable.

Any Background, No Squinting

When you're shooting outdoors with a large studio flash, there is no background that you can't use. Additionally, you won't have to deal with the squinting, watery eyes of your subject (which often happens when you use reflectors).

Main Light

When I use flash outdoors, I use basically the same lighting setup as in the studio. For the main light, I use a large softbox, umbrella, or (most often) octobox equipped with the most powerful Alien Bees head I own, allowing me to balance even the brightest scene. This light is placed 45 to 90 degrees from the camera position, at a starting height that has the light box roughly level with the subject's chest.

Contrast

Generally, the diffusion panel is left in place; this makes its output a better match for the lighting around the subject, which is typically quite soft. When I pose the subject in a backlit area with a majority of the scene and subject in direct sun-light, however, I will take the diffusion panel off to balance the more contrasty background with the lighting produced by the flash.

Fill Light

With your flash main light, you can raise the exposure on the subject by up to 2 stops and still use the ambient light as the fill. When the light on the subject needs to be increased by more than 2 stops to balance with the light on

Where Does the Fill Go?

The fill light must be feathered off the ground or it will blow out the foreground directly in front of the subject. I often mount this light on a background stand to angle it up toward the subject and away from the ground.

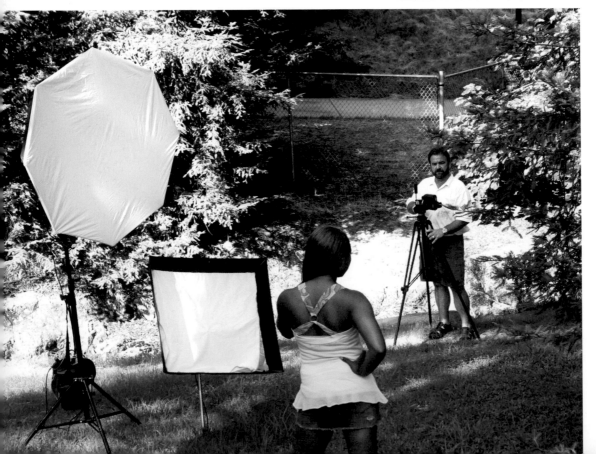

Left and facing page. The main light (octobox) and fill light (softbox) were positioned just as for a studio portrait.

the background, the ambient light on the subject will not be enough to fill the shadows adequately. This means you need to bring in another light or a reflector to fill the shadow so both the

When I use flash outdoors, I use basically the same setup as in the studio.

highlight and shadow will record. When flash fill is needed, I place a smaller softbox below the subject. This produces a lighting effect that is similar to what we have been creating so far with the natural light paired with a reflector under the face of the subject.

Variety Is Critical

The days are over when a photographer could develop one look (one style of lighting, approach to background selection, or posing strategy) and use it for every session.

Through the media, our consumers are exposed to the most creative images in the world—and you are going to offer them one style of lighting to produce one look? That just won't fly.

While truly mastering even one style of lighting still puts you ahead of many of the shooters in today's marketplace (saturated as it is by "semipros"), it doesn't make you stand out in this crowded industry.

So look for ways to push yourself. Experiment with new lighting setups, figure out how to get flattering results in unexpected locations, and—most of all—keep your mind open to new ideas that might enhance your work (and your sales).

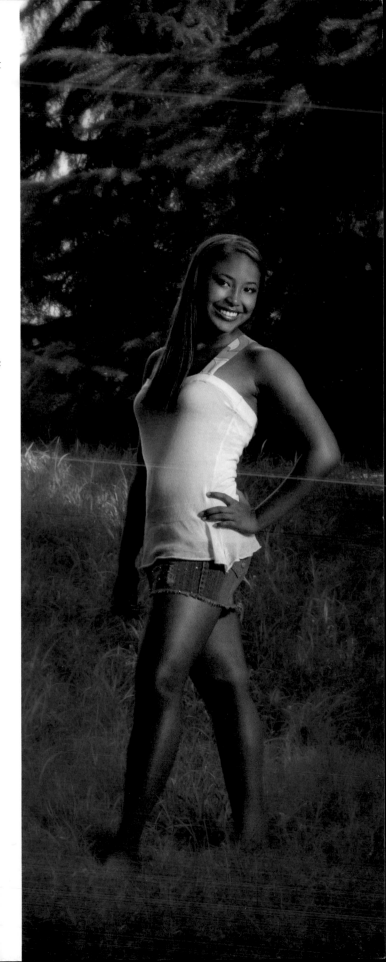

Maintain a Darker Background

Let's say that we are working near a tree in a shaded area where the ambient light meters $\frac{1}{125}$ second at f/5.6. The background is 2 stops brighter—$\frac{1}{125}$ second at f/11. How can you get a balanced exposure? Setting the main light at f/8.5 will make it $1\frac{1}{2}$ stops greater than the fill source (the ambient light), for an overall ratio of 3:1 (more on ratios in lesson 41). For more contrast, say a 4:1 ratio, you'd set the main light 2 stops over the fill-light (ambient) reading.

Critical Concepts

Flash Exposure. With flash, your shutter speed is limited by your camera's maximum flash sync speed. This is the shortest shutter speed at which the shutter curtains are completely open, allowing the entire frame to be simultaneously exposed to the burst of flash. It is typically between $\frac{1}{125}$ and $\frac{1}{500}$ second. If you exceed this speed, you'll see a dark band across part of your image, indicating that the shutter curtain blocked the flash exposure. Therefore, you only consider the f-stop when setting the flash.

Ambient Exposure. Because it is a continuous light source, the natural light will be affected by both the shutter speed *and* the f-stop. As long as you do not exceed the maximum flash sync speed, this means you can use the shutter speed to adjust the exposure of the ambient-lit areas (the background/foreground) without affecting the flash-lit areas (the subject). (*Note:* If the ambient light is the only fill source, you may have to compensate when reducing the ambient exposure.)

When all is said and done, then, for the 3:1 lighting situation, your fill light would be at f/5.6, your main light would be at f/8.5, and your background light would be at f/11. The

Night portraits are made possible utilizing the same controls over lighting.

half-stop difference (f/8.5 to f/11) between the main light and the background will be workable as long as the color of the background is relatively dark. If it were greenery, for example, you'd be fine; if it were a white building, however, you would need to make some corrections.

Darken a Brighter Background

To darken a bright background, you need to do something counterintuitive: you need to increase the amount of light on your subject. Since we can't meaningfully change the lighting falling on a sunlit expanse, controlling how the background appears is really about controlling the exposure level of the subject in relation to the exposure level of the background.

There are three limiting factors in this process: the power of your lights, the maximum shutter speed at which your camera syncs with flash, and the amount of fill (ambient).

Let's say you were working in the same scenario just described, but with a white background that you wanted to darken. The back-

ground metered $^1/_{125}$ second at f/11, so to darken it in your image, you could set your main light to f/11, raise your fill to f/5.6.5 (to maintain the same light ratio on the subject), and adjust your shutter speed to $^1/_{500}$ second. Your background would now be 2 stops darker than the main light on the subject.

But wait . . . if the fill source is the ambient light and it meters at f/5.6, how are we going to get it to f/5.6.5? Simple! We can use any additive light source. This could be a white or silver reflector, but an additional flash will give you the greatest ability to darken the background. This is because its effect is controlled solely by the f-stop, not the shutter speed.

Capture Detail in a Very Dark Background

Night portraits are made possible utilizing the same controls over lighting. You simply use a very slow shutter speed, continuing the exposure after the shutter has popped (this is called "drag-

Below and facing page. Adding flash on the subject let me subdue the background in relation to her.

ging the shutter"). The longer exposure time allows low levels of ambient lighting to continue to register on the background after the burst of flash has lit the subject. This makes it possible to record all the colors of the skyline after sunset or all the lights in an evening streetscape.

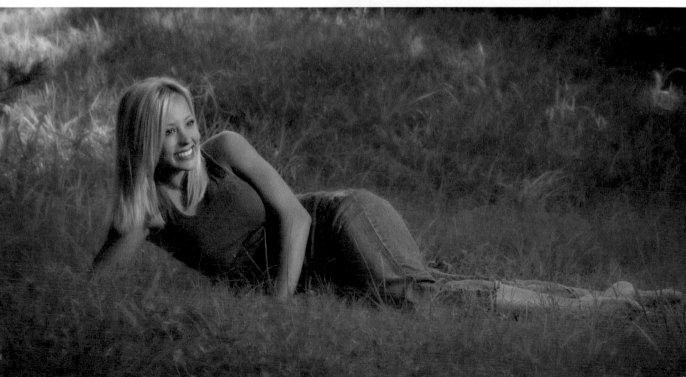

How to Meter

When using flash, metering the scene for a full-length portrait can be a little confusing.

Reading 1. I start by taking an ambient reading on my light meter. I do this by standing at the subject position and pointing the meter back toward the camera.

Flash Meters

The device seen below is called a light meter. I realize that pointing this out sounds like a joke, but it almost isn't. Although most photographers have one of these little devices, many have quit using them. Believe it or not, shooting a test frame and looking at the back of your camera is not the same thing as metering/controlling your lighting.

Using a light meter is important for achieving professional results.

Readings 2 and 3. I also take at least two additional readings: an ambient reading of the background, and a reading with the incident dome pointed up to the sky. This allows me to visualize the light intensity from each angle.

Reading 4. If I am working with an obstruction near the subject, to one side or the other, I take a fourth reading to measure the amount of light on the side of the obstruction. That will be the amount of fill I have to work with.

Based on these readings, I can decide on the lighting I need to balance the scene.

Most photographers working in this situation just use the calculated amount of ambient light from the subject to the camera as the amount of fill they have to work with—and this is why so many of them find it difficult to control the shadows in their outdoor portraits. A dark (subtractive) obstruction will reduce the amount of fill; a white or silver (reflective) obstruction will increase it. If the effect of these surfaces is not calculated into your lighting setup, it could compromise your ability to achieve the desired lighting ratio.

Based on these readings, I can decide on the lighting I need to balance the scene for the results I want to achieve. This brings us back to a point I've made before: you have to know what you want.

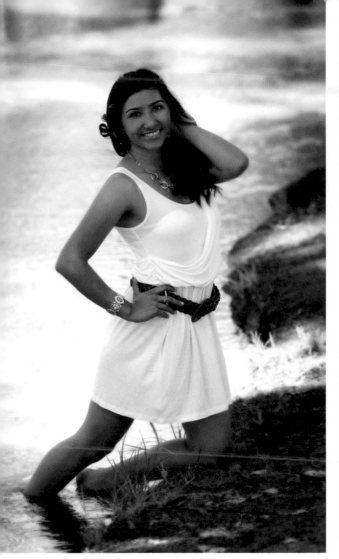
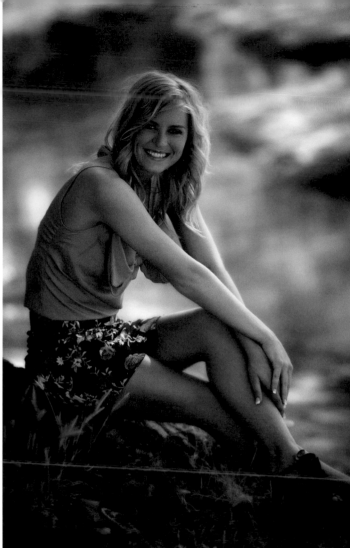

How do you want the background to look? For the girl in the white dress, letting the stream go lighter and more neutral produced the best look. For the girl in more colorful attire, subduing the river area in the background produced the look I wanted, bringing out the color of the reflected foliage.

Know What You Want

As the photographer, you should determine your camera and light settings based on how you want your images to look. You should not just meter and say, "Oh well, what the heck? I guess I'll be shooting at f/11." You need to know what look you are trying to produce; you have to previsualize. Balancing flash with an ambient light source that is out of your control complicates this process and can force you to make some compromises—but you should still be making conscious decisions within the constraints of the environment.

Keep Controlling the Fill!

If dark obstruction to one side of my subject provides little light for the fill side of the frame, I place a reflector to bring up the shadow side of the subject as needed. If a white or silver obstruction is putting too much fill on the shadow side, the problem can be fixed by putting a gobo between the reflective surface and the subject.

Many Looks in One Location

As the photographer—the *creator* of the portrait—you need to be in control of the final outcome, taking advantage of all the controls at your disposal to achieve the results you want. You'll find that many different looks are possible at a single location.

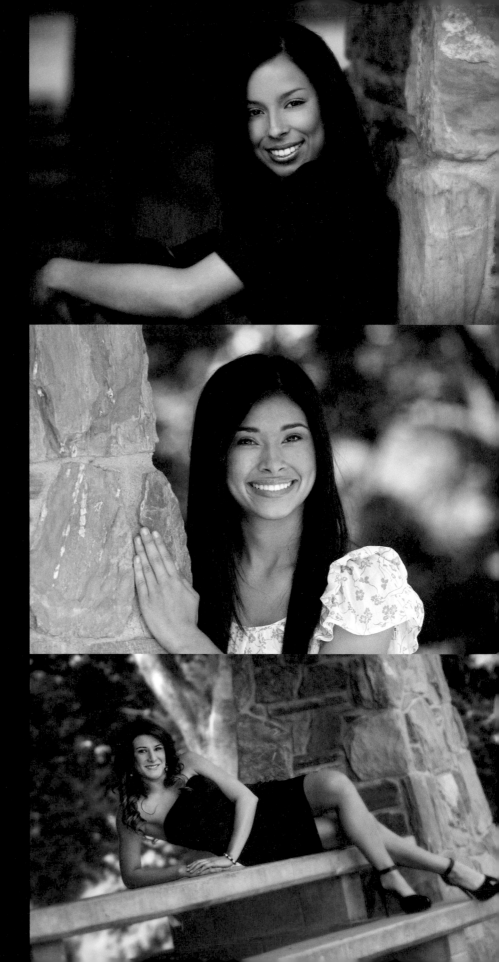

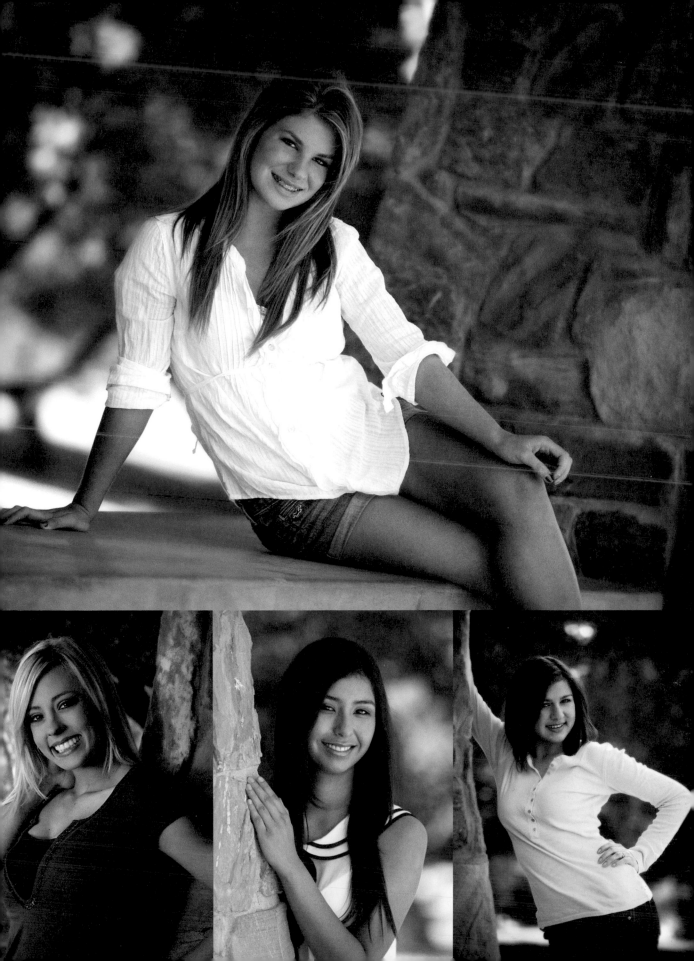

Calculating

Light ratios are used to describe the intensity of the main light relative to the intensity of the fill light. If a portrait is said to have a 4:1 ratio, then the highlight side (lit by the main light) is four times brighter than the shadow side.

This is where things get tricky. You might think, "Well, if the highlight side is four times brighter than the shadow side, there must be four stops more light falling on it." Not true. Each 1-stop increase actually doubles the

A lower ratio provides just enough shadow to reveal the contours of the face.

amount of light on the subject. Therefore, when the main light source meters 2 stops higher than the fill light source, you have a 4:1 ratio. If the main light meters 1.5 stops brighter than the fill light, you have a 3:1 ratio.

Higher ratios indicate a greater difference in highlight/shadow intensity that reveals contours and textures. Lower ratios show less differentiation between the highlights and shadows, which tends to smooth out shapes and textures.

What's the "Right" Ratio?

When using studio light outdoors, you'll end up with lower lighting ratios than you would in the studio, but you still need to be sure that your light adds enough shadow to create depth and the sense of a third dimension in the final images. I usually start out with a 3:1 lighting ratio (my main light meters 1.5 stops greater than my fill light) for subjects with light to medium

You still need to be sure that your light adds enough shadow to create depth.

skin tones and wearing neutral colors. If I were photographing a group of subjects with darker skin tones and/or the individuals were wearing darker clothing, I would increase the fill to meter 1 stop less than the main light.

Lighting ratios also change with the hardness/softness of the light. For example, while

A higher ratio provides greater contrast to more clearly define the shape of the subject's face.

a fair-skinned person being lit with a softbox might look great with a 3:1 ratio, that same 3:1 lighting ratio will not fill the shadow properly if you change the main light from a softbox to a parabolic. Harder light produces heavier/darker shadows and requires more fill (meaning a lower lighting ratio, like 2:1). This is true of both studio lighting and natural lighting.

Can We Simplify This?

The number of variables involved here is one reason why my fill source is so often a reflector. With a reflector, what you see with your eyes is exactly what you get. This makes adjusting the fill for each subject, pose, outfit, or background much more fluid and intuitive.

LCD Preview

Back in the days of film, you had to be very efficient with meter readings to make strobe lighting look natural outdoors. With digital we have instant previews, which makes life much easier. I get everything metered the way I want, then use the preview to fine-tune the lighting to get the exact look I want.

To make this process as accurate as possible, an LCD shade is an excellent investment. It is a bellows-type shade that completely covers the LCD screen. It also features a magnifier for easy viewing. This really helps move the process along, because trying to see your preview in glaring sunlight is almost impossible.

Histogram

You must also watch your histogram. A preview is nice, but often an image looks fine on the camera's LCD screen and it isn't until you bring

The camera's LCD screen is a valuable exposure tool—but on sunny days at the beach it can be just about impossible to see.

For an average scene, seeing the data all crowded up on the left side of the histogram can indicate that the image is underexposed.

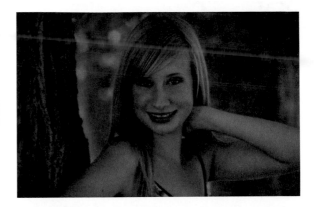

For an average scene, a histogram that covers the full range of tones and tapers down at the ends usually indicates a good exposure.

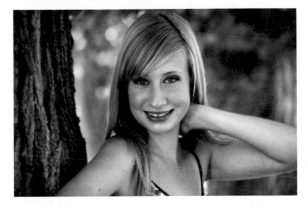

For an average scene, a histogram that stacks up at the far right can indicate overexposure—and a loss of detail in the highlights.

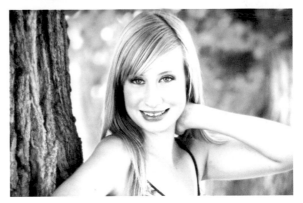

it up in Photoshop that you realize how dark it is. Checking your histogram on the camera will help ensure that you are using as much of the complete tonal range as possible.

A histogram is a graphic representation, unique to each image, that shows the number of pixels at each brightness level, from black at the left to white at the right. For most average scenes, you're looking for the data to cover the whole range of tonalities without stacking up at the left edge (indicating loss of shadow detail and possible underexposure) or the right edge (indicating loss of highlight detail and possible overexposure). Reading histograms takes a little practice, but once you master them you'll have a nice objective exposure tool at your fingertips.

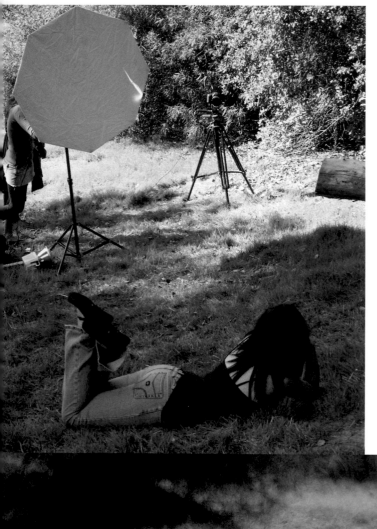

Practical Example 1

As you deal with lighting outdoor portraits, you will have to modify your approach to fit the scene and the subject's pose. In our first example (below), the natural light for the subject lacked direction; there was a grove of trees, and most of the lighting came from overhead. With the subject lying on the ground, the lower light that I often use outdoors was turned off to avoid the grass in front of it becoming overexposed. That would have given the scene an unnatural look.

When I metered this scene, I wanted to keep the background from washing out. Using an exposure of $^1/_{125}$ second at f/11 produced attractive lighting on the face while maintaining beautiful lighting on the background and the rest of the subject. The single flash with an

An octobox provided an appropriate main light. The fill was provided by the sunlight hitting the grass surrounding the subject.

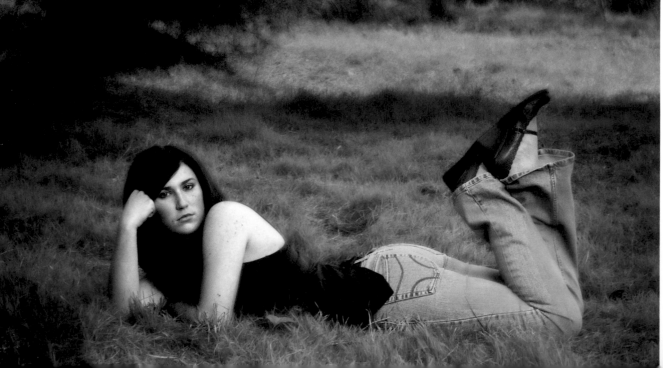

octobox provided an appropriate main light. The look of the light on the subject (lit by the flash) is well coordinated with the look of the lighting on the background (lit by the sun). The fill was provided by the sunlight hitting the grass around the subject.

Practical Example 2

In this same area, I created a second image of the same senior, posed up off the ground on a tree limb (right). For this image, I used the same main light, but added a smaller softbox for the lower light.

I used the same main light, but added a smaller softbox for the lower light.

I metered each of these lights separately. In outdoor setups, my main is generally 1.5 to 2 stops greater than the fill source. Once I established the ratio of lighting between these two lights, I metered both lights together and used that combined reading to determine setting to balance the background.

For example, if the main light read f/11, I'd start out with the lower light metering f/5.6. Then, with both lights adjusted, I would meter both units when fired at the same time. In this case, it was almost f/16. So, after metering the background, I then set the aperture at f/16 and adjusted the camera's shutter speed to lighten or darken the background as desired.

Here, I used the same main light, but added a smaller softbox for fill from below the subject.

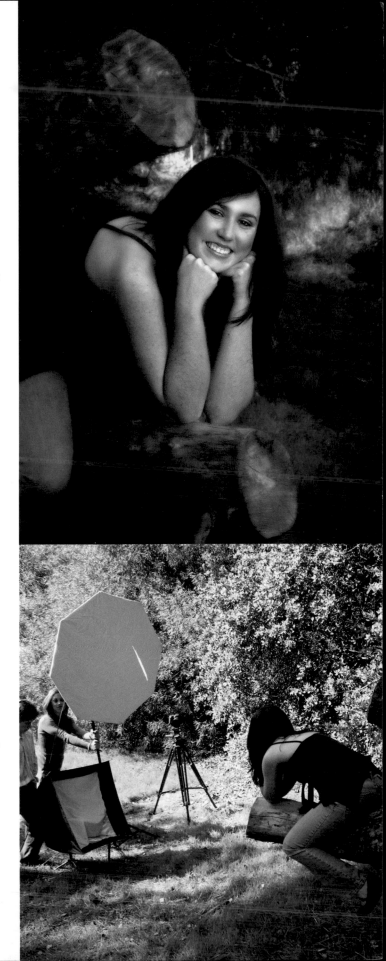

Turning the face toward the main light (left) illuminates the mask of the face and creates shadows that shape it nicely. Turning the face away from the main light (right) creates unflattering shadows. In particular, the nose shadow brings too much emphasis to a part of the face many subjects feel is already too big.

Our discussion of lighting would be incomplete without considering posing. Professional lighting produces shadows and highlights that give a three-dimensional look on a two-dimensional piece of paper. Where the highlights fall (what is accentuated) and where the shadows fall (what is minimized) is critical.

In part, this will be determined by the lighting itself. However, the posing *in relation to the lighting* is a key factor—especially in outdoor scenarios. As we've seen throughout this book, adjusting the subject's position relative to the light is a far more feasible solution to many challenges than changing the ambient lighting itself.

The Face

As noted in lesson 41, I tend to work with a lighting ratio in the 3:1 to 4:1 range. This means if the face is turned away from the main light source, the shadow on the side of the nose will increase, making the nose appear larger. There are two solutions: turn the face more toward the main light, or decrease the ratio.

Shadowing gives us a great way to reduce the appearance of body size.

Decreasing the ratio produces a flat look. If, instead, you turn the face toward the main light source, you light the mask of the face without increasing shadowing in areas where it shouldn't

When the hips and shoulders are square to the camera (left), the body looks wide. Turning the body away from the main light (right) is much more flattering. The shadows now do double duty, slimming the waist and hips while enhancing the bust.

be. An added bonus: turning the head also stretches out the neck and reduces the appearance of any double chin.

The Body

Shadowing also gives us a great way to reduce the appearance of body size. I tend to pose the subject with their body in a side view, facing the shadow side of the frame. This presents the narrowest view of the body and puts much of the body in shadow to further slim the figure.

Is Slimming *So* Important?

In my experience, 97 percent of portrait subjects (even ones who are already trim) would like to look slimmer. Therefore, my posing and lighting styles tend to focus on achieving that objective.

One of the most important decisions we make when creating a portrait is how much of the person should show within the frame. If a tight head-and-shoulders look is needed, this will dictate (in my approach) the use of natural light rather than flash. For a full-length portrait, I might switch to flash—but I'll also need to control the exposure and composition of a larger background area.

The Purpose of the Portrait

The more fashionable the portrait, the more leeway you may have when posing and lighting the person. The more conservative the purpose (for business as an example), the more restraint you must use. Understand the expectations of the client and don't treat every shoot as an experiment in creative lighting and posing.

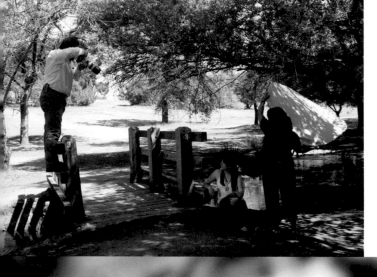

For closer views, where the lighting on the face is critical, I prefer to use the natural light rather than adding flash.

Most women are concerned about their hips (lower image). To ensure your subject feels great about her portraits, don't show them (top photo).

The Subject's Appearance

Sometimes, the subject's appearance dictates the best choice for their portraits. For heavier subjects, a beautifully lit waist-up portrait is often the right choice.

The Background and Existing Light

If only a small area of the background is usable, a full-length portrait may not be feasible. Conversely, if you need to use the available light only but it's not perfect on the face, pulling back for a full-length image might yield a usable look.

How Can I Put This . . . ?

What should you do when a subject wants to do a pose you know they shouldn't? Fortunately, you can handle it without looking unprofessional. For example, if I see a heavier girl arrive with boxes of shoes, I explain, "Many ladies buy matching shoes for every outfit. But when you order your wallets for family and friends, those full-length poses make it hard to see your face." (This lets her know that not all poses should be done full-length.) I continue, "Most women worry about looking thin—especially in their hips and thighs. That's why most portraits are done from the waist up." Then I ask, "Now, are there any outfits you want to take full-length, or do you want to do everything from the waist up?" She will usually decide she wants everything from the waist up. This avoids telling her she *can't* take full-lengths, or being brutally honest and telling her she *shouldn't* take them.

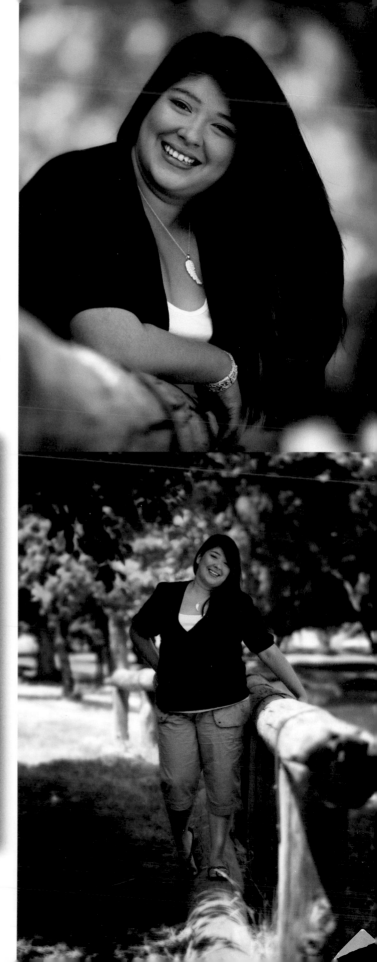

Once you've gone to the trouble of finding (or creating) the right lighting on your subject, don't just settle for producing one image. Try a variety of subtle posing variations and expressions to give your client plenty of good options. Try a different camera position or angle to change the look of the background in relation to the subject. If you're able to shoot with just available light (or available light and a reflector), move around the location and make as much use of its potential as you can.

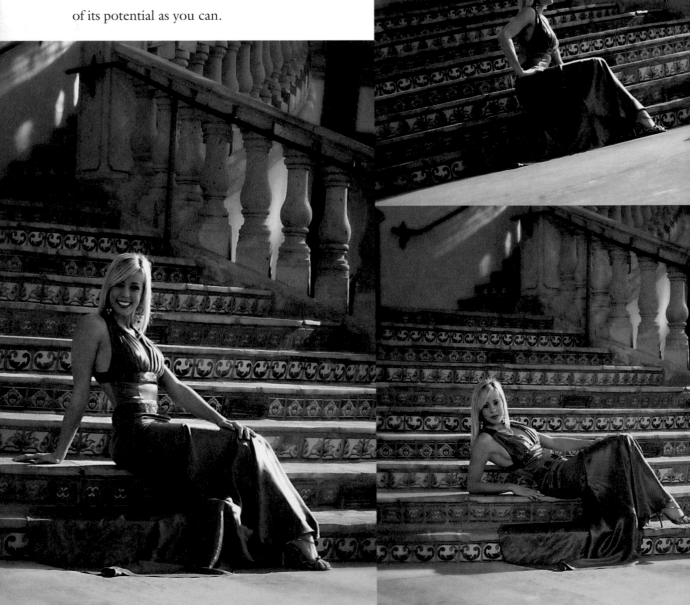

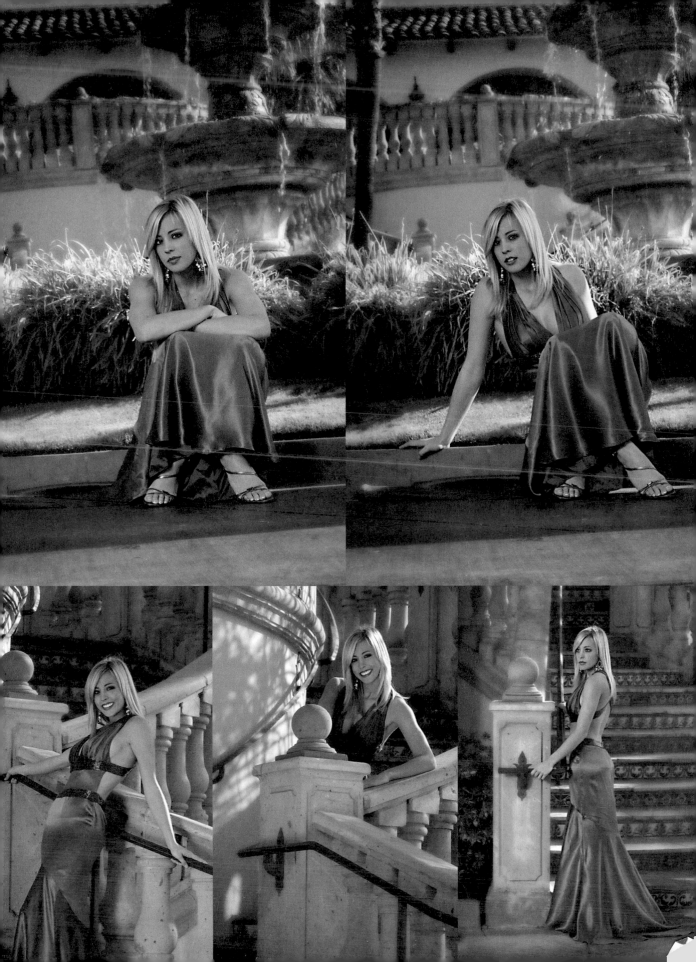

As portrait photographers, we typically think that our job is to create a flattering image of the subject, but it's not. Our job is to create a portrait that flatters the subject *and* entices the viewer to focus first on the portrait and then specifically on the subject. This comes from co-ordinating every detail included in the frame.

Planning Is Critical

It takes so long to complete a painting that no painter would ever just grab someone off the street, sit them down in a chair and, without planning or thought, begin painting. Time forces the artist to plan. Unfortunately, photographers tend to be obsessed with speed, firing off frame after frame and hoping that spontaneity and volume will take the place of planning and artistic vision.

Maybe we get this from watching fashion photographers. They do tend to work quickly, but that's because they are also wizards at planning. Before they touch the camera, they have planned the wardrobe, makeup, hairstyle, accessories, camera angles, composition, basic posing, and every other detail. They know exactly what the outcome of the session will be and, with professional models, can rapidly produce great images.

As a portrait photographer, you are more like the painter than the fashion photographer. You probably don't have the fashion photographer's budget to hire a stylist, set designer, assistants, or professional models, so forget about the "digital is free—I'll shoot a million frames" mind-set. Imagine, instead, you are going to create five images using five frames. If you approach each session with that attitude, you'll start to grow as a photographer—and you won't need to rely on luck or the law of averages.

Clothing

The clothing controls two aspects of an image: the style of the portrait (elegant, trendy, casual) and the basic color scheme of the portrait. In a perfect world, you would have scenes that were made up of the same colors as the client's clothing. This way, the focus of the portrait would be your client, not her outfit.

In the real world, photographers do not have complete control over the colors that will make up the backgrounds of their outdoor portraits, and clients aren't generally interested in wearing only green or brown clothing.

Casual clothing pairs with a casual pose, simple setting, and gentle lighting for a cohesive look.

In medium to dark brown and green foliage scenes, clothes in maroon, plum, medium to dark blue, and darker shades of red will coordinate well. Clothes in pastel tones work with backgrounds that are lighter in color and tone.

Makeup and Hair

Most clients have a way that they like to wear their hair and makeup and, for most of them, it works. They automatically apply their makeup a little darker for more elegant outfits and wear lighter makeup with more casual clothing. They tend to wear their hair down with most clothing, and sometimes sweep it up for more elegant clothing or pull it back for very casual shots.

Posing

The pose you select for your client should suit their clothing selection, hair, makeup, and the scene.

When all of these elements come together, the result is a portrait with style.

Casual clothes and scenes call for "resting" poses—versions of the natural positions people take when they are watching television or talking with a friend. Casual poses are perfect when the portraits are for the parents or family. Families prefer natural, comfortable poses that remind them of how they see the subject each day.

Elegant clothing requires more dramatic poses designed to increase the subject's visual impact. In these poses, the hands and arms are posed to create interesting lines or fill the

When the subject switched to more formal clothing, I switched to a more structured setting, a more formal pose, and a stronger lighting look.

composition to heighten the appeal of the look. These poses are used for more formal looks or when the subject wants to look alluring (such as in a portrait created for their romantic interest).

Lighting

The look of the lighting should be harmonious with all the other decisions. If the client is wearing a summer dress at the beach, the lighting should look light and airy. If your subject is wearing jeans and a leather jacket in a gritty urban streetscape, more dramatic lighting is probably in order.

When all of these elements come together, the result is a portrait with style—a portrait that makes the subject look great but also engages the viewer.

Bring it All Together

When all of the elements you choose to include in the frame are well-coordinated, the portrait will be more than the sum of its parts. In addition to making the subject look good, it will be an engaging image that draws viewers into the moment.

118

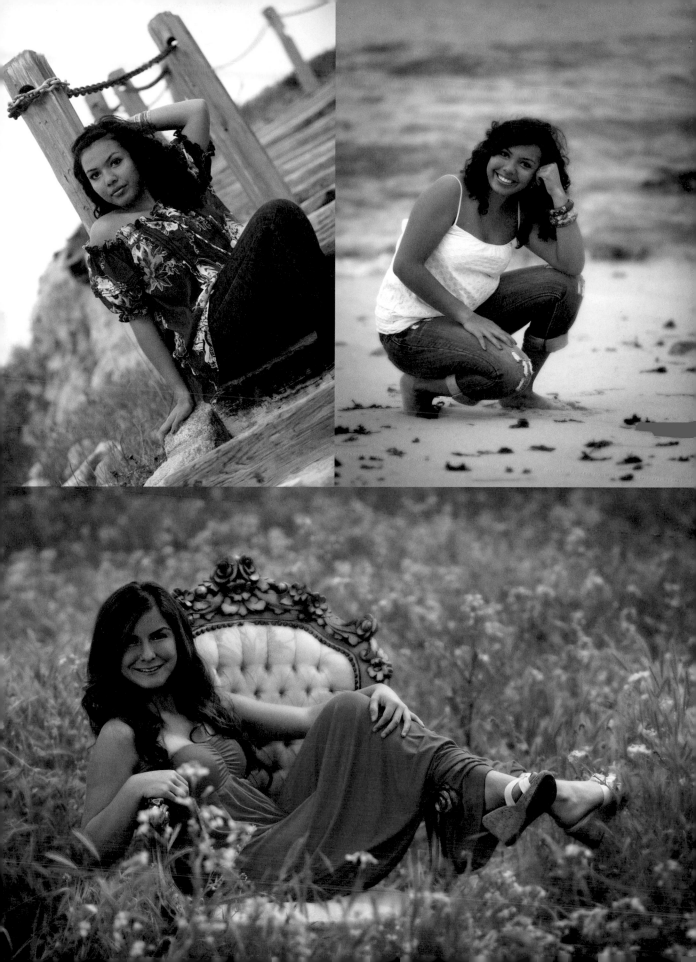

All the preparation and great lighting in the world won't put money in your pocket if the client doesn't show up. Here is how we deal with the issue.

The Problem

Sessions done on location have a higher-than-average amount of no-shows. I remember when we used to schedule an appointment for anyone who called in. Unfortunately, many of them seemed to think, "Sure, I'll schedule that appointment—if I change my mind, I just won't show up." As a result, we had many clients each week who would call to cancel, using excuses like, "My friends asked me to go shopping, so I won't make it in today," or "I stayed up late, so I'm too tired to do the session today." On any given day, 20 to 50 percent of our sessions would not show up.

Sessions done on location have a higher-than-average amount of no-shows.

At that time, our solution (or at least what we thought of it as a solution) was to overbook the outdoor shooting days, just like doctors do, to ensure my time wasn't wasted. The problem was that, on occasion, everyone would show up, causing us to run way behind at the end of the day—and that was frustrating for both us and the clients.

Above and facing page. Clients who are serious about having portraits made generally won't object to prepaying for their session.

The Solution

Fortunately, the issue of no-shows is an easy problem to fix: simply ask each client to pay for their session when they book it. We explain, both on the phone and in writing, that we require 72 hours advance notice of any cancellation. If this proper notice is given, the appointment will be rescheduled, but not refunded. If the client is resistant, we explain that it is the same as booking a hotel room; you must pay up front to have it reserved for you. Likewise, our time is reserved for the client, so they must pay to reserve it.

This sounds scary to many photographers, but it completely weeds out the clients who are not serious about being photographed. There will be a few people who say, "That's ridiculous! The Jones studio doesn't do that." If you hear those words, you'll know that you have just weeded out a client who would not have shown up anyway.

Does it Really Work?

During the final year when we accepted appointments *without* prepayment, we had one senior who canceled and rescheduled her appointment eight times over the course of her senior year! When we finally asked for advance payment on the session, she was there 30 minutes early.

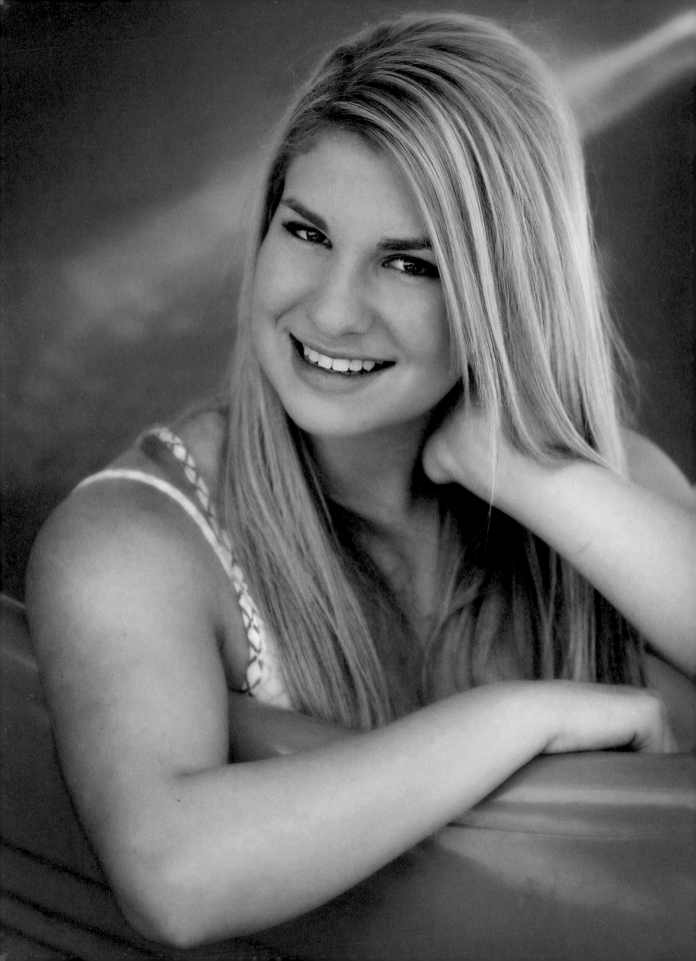

Conclusion

This profession has allowed me to live very well for a very long time. I have been able to enjoy my life personally while doing what I love to do professionally. I have seen parts of the world that few photographers will ever see—not because they lack the potential, but because they consider themselves artists first and business-people second.

Many photographers will read this book, e-mail me a thank-you note, and use very little of the information; it is human nature to settle—not changing, not growing, and not having to become more than we already are. So, while I hope you enjoyed reading this book, I hope even more that you *use* the information to better your business and your photography, which in turn will better your life.

Providing clients with high-quality outdoor portraiture, while scheduling it to profit your business, isn't always easy, but it is very satisfying and profitable.

Good luck,
Jeff Smith

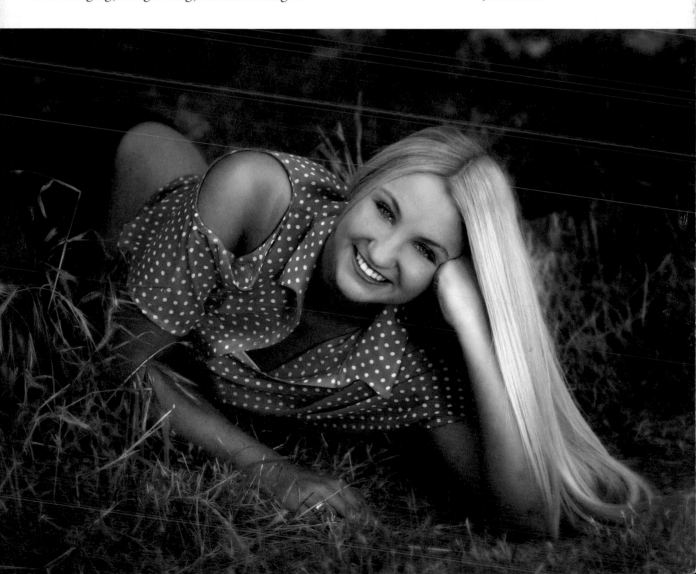

Index

OTHER BOOKS FROM
Amherst Media®

DON GIANNATTI'S Guide to
Professional Photography

Perfect your portfolio and get work in the fashion, food, beauty, or editorial markets. Contains insights and images from top pros. *$39.95 list, 7.5x10, 160p, 220 color images, order no. 1971.*

Lighting Essentials: LIGHTING FOR
TEXTURE, CONTRAST, AND DIMENSION

Don Giannatti explores lighting to define shape, conceal or emphasize texture, and enhance the feeling of a third dimension. *$34.95 list, 7.5x10, 160p, 220 color images, order no. 1961.*

Just One Flash

Rod and Robin Deutschmann show you how to get back to the basics and create striking photos with just one flash. *$34.95 list, 8.5x11, 128p, 180 color images, 30 diagrams, index, order no. 1929.*

TUCCI AND USMANI'S
The Business of Photography

Take your business from flat to fantastic using the foundational business and marketing strategies detailed in this book. *$34.95 list, 8.5x11, 128p, 180 color images, index, order no. 1919.*

WES KRONINGER'S
Lighting Design Techniques
FOR DIGITAL PHOTOGRAPHERS

Create setups that blur the lines between fashion, editorial, and classic portraits. *$34.95 list, 8.5x11, 128p, 80 color images, 60 diagrams, index, order no. 1930.*

CHRISTOPHER GREY'S
Advanced Lighting Techniques

Learn how to create stylized lighting effects that other studios can't touch with this witty, informative guide. *$34.95 list, 8.5x11, 128p, 200 color images, 26 diagrams, index, order no. 1920.*

DOUG BOX'S
Flash Photography

Doug Box helps you master the use of flash to create perfect portrait, wedding, and event shots anywhere. *$34.95 list, 8.5x11, 128p, 345 color images, index, order no. 1931.*

500 Poses for Photographing
High School Seniors

Michelle Perkins presents head-and-shoulders, three-quarter, and full-length poses tailored to seniors' eclectic tastes. *$34.95 list, 8.5x11, 128p, 500 color images, order no. 1957.*

500 Poses
for Photographing Men

Michelle Perkins showcases an array of head-and-shoulders, three-quarter, full-length, and seated and standing poses. *$34.95 list, 8.5x11, 128p, 500 color images, order no. 1934.*

LED Lighting: PROFESSIONAL TECHNIQUES
FOR DIGITAL PHOTOGRAPHERS

Kirk Tuck's comprehensive look at LED lighting reveals the ins-and-outs of the technology and shows how to put it to great use. *$34.95 list, 7.5x10, 160p, 380 color images, order no. 1958.*

Off-Camera Flash
TECHNIQUES FOR DIGITAL PHOTOGRAPHERS

Neil van Niekerk shows you how to set your camera, choose the right settings, and position your flash for exceptional results. *$34.95 list, 8.5x11, 128p, 235 color images, index, order no. 1935.*

Nikon® Speedlight® Handbook

Stephanie Zettl gets down and dirty with this dynamic lighting system, showing you how to maximize your results in the studio or on location. *$34.95 list, 7.5x10, 160p, 300 color images, order no. 1959.*

THE DIGITAL PHOTOGRAPHER'S GUIDE TO
Light Modifiers SCULPTING WITH LIGHT™

Allison Earnest shows you how to use an array of light modifiers to enhance your studio and location images. *$34.95 list, 8.5x11, 128p, 190 color images, 30 diagrams, index, order no. 1921.*

DOUG BOX'S
Available Light Photography

Popular photo-educator Doug Box shows you how to capture (and refine) the simple beauty of available light—indoors and out. *$39.95 list, 7.5x10, 160p, 240 color images, order no. 1964.*

Understanding and Controlling Strobe Lighting

John Siskin shows you how to use and modify a single strobe, balance lights, perfect exposure, and more. *$34.95 list, 8.5x11, 128p, 150 color images, 20 diagrams, index, order no. 1927.*

THE BEST OF **Senior Portrait Photography,** SECOND EDITION

Rangefinder editor Bill Hurter takes you behind the scenes with top pros, revealing the techniques that make their images shine. *$39.95 list, 7.5x10, 160p, 200 color images, order no. 1966.*

Flash Techniques for Location Portraiture

Alyn Stafford takes flash on the road, showing you how to achieve big results with these small systems. *$34.95 list, 7.5x10, 160p, 220 color images, order no. 1963.*

Master Posing Guide for Portrait Photographers, 2nd Ed.

JD Wacker's must-have posing book has been fully updated. You'll learn fail-safe techniques for posing men, women, kids, and groups. *$39.95 list, 7.5x10, 160p, 220 color images, order no. 1972.*

Christopher Grey's Posing, Composition, and Cropping

Make optimal image design choices to produce photographs that flatter your subjects and meet clients' needs. *$39.95 list, 7.5x10, 160p, 330 color images, index, order no. 1969.*

Also by Jeff Smith . . .

Step-by-Step Posing for Portrait Photography

Jeff Smith provides easy-to-digest, heavily illustrated posing lessons designed to speed learning and maximize success. *$34.95 list, 7.5x10, 160p, 300 color images, order no. 1960.*

JEFF SMITH'S GUIDE TO
Head and Shoulders Portrait Photography

Make head and shoulders portraits a more creative and lucrative part of your business. *$34.95 list, 8.5x11, 128p, 200 color images, index, order no. 1886.*

JEFF SMITH'S **Senior Portrait Photography Handbook**

Improve your images and profitability through better design, market analysis, and business practices. *$34.95 list, 8.5x11, 128p, 170 color images, index, order no. 1896.*

Corrective Lighting, Posing & Retouching FOR DIGITAL PORTRAIT PHOTOGRAPHERS, 3RD ED.

Jeff Smith shows you how to address and resolve your subject's perceived flaws. *$34.95 list, 8.5x11, 128p, 180 color images, index, order no. 1916.*

JEFF SMITH'S
Studio Flash Photography

This common-sense approach to strobe lighting shows photographers how to tailor their setups to each individual subject. *$34.95 list, 8.5x11, 128p, 150 color images, index, order no. 1928.*

Posing for Portrait Photography

A HEAD-TO-TOE GUIDE FOR DIGITAL PHOTOGRAPHERS, 2ND ED.

Jeff Smith shows you how to correct common figure flaws and create natural-looking poses. *$34.95 list, 8.5x11, 128p, 200 color images, index, order no. 1944.*

75 Portraits
by Hernan Rodriquez

Conceptualize and create stunning shots of men, women, and kids with the high-caliber techniques in this book. *$39.95 list, 7.5x10, 160p, 150 color images, 75 diagrams, index, order no. 1970.*

Location Lighting

Stephanie Zettl shows wedding and portrait photographers how to create elegant, evocative, and expressive lighting for subjects in any location. *$39.95 list, 7.5x10, 160p, 200 color images, 5 diagrams, order no. 1990.*

Direction & Quality of Light

Neil Van Niekerk shows you how consciously controlling the direction and quality of light in your portraits can take your work to a whole new level. *$39.95 list, 7.5x10, 160p, 195 color images, order no. 1982.*

On-Camera Flash TECHNIQUES FOR
DIGITAL WEDDING AND PORTRAIT PHOTOGRAPHY

Neil van Niekerk teaches you how to use on-camera flash to create flattering portrait lighting anywhere. *$34.95 list, 8.5x11, 128p, 190 color images, index, order no. 1888.*

THE ART AND BUSINESS OF HIGH SCHOOL
Senior Portrait Photography,
SECOND EDITION

Ellie Vayo provides critical marketing and business tips for all senior portrait photographers. *$39.95 list, 7.5x10, 160p, 200 color images, order no. 1983.*

Backdrops and Backgrounds
A PORTRAIT PHOTOGRAPHER'S GUIDE

Ryan Klos' book shows you how to select, light, and modify man-made and natural backdrops to create standout portraits. *$39.95 list, 7.5x10, 160p, 220 color images, order no. 1976.*

BILL HURTER'S
Small Flash Photography

Learn to select and place small flash units, choose proper flash settings and communication, and more. *$34.95 list, 8.5x11, 128p, 180 color photos and diagrams, index, order no. 1936.*

Studio Lighting Anywhere

Joe Farace teaches you how to overcome lighting challenges and ensure beautiful results on location and in small spaces. *$34.95 list, 8.5x11, 128p, 200 color photos and diagrams, index, order no. 1940.*

Hollywood Lighting

Lou Szoke teaches you how to use hot lights to create timeless Hollywood-style portraits that rival the masterworks of the 1930s and '40s. *$34.95 list, 7.5x10, 160p, 148 color images, 130 diagrams, index, order no. 1956.*

Family Photography

Christie Mumm shows you how to build a business based on client relationships and capture life-cycle milestones, from births, to senior portraits, to weddings. *$34.95 list, 8.5x11, 128p, 220 color images, index, order no. 1941.*